Paola Malipiero Art Series

Canaletto

Canaletto

Author: Terisio Pignatti

Translator: Murtha Baca

Barron's

CONTENTS

ACKNOWLEDGMENTS

The editors wish to thank for their kind
assistance:

Her Majesty Queen Elizabeth of England
The Duke of Beaufort
Countess Cecilia Giustiniani

The directors of the following collections,
museums, galleries, and estates:

The Ashmolean Museum, Oxford
The Cassa di Risparmio, Venice
The Dulwich Gallery, London
E. V. Thaw and Co., New York
The Uffizi Gallery, Florence
The National Gallery of Ancient Art, Rome
The Academy, Venice
The Hamburger Kunsthalle, Hamburg
The Kunsthistorisches Museum, Vienna
The Correr Museum, Venice
The Poldi Pezzoli Museum, Venice
The Museum of Fine Arts, Boston
The Narodni Galerie, Prague
The National Gallery, London
The National Gallery of Canada, Ottawa
The National Museum of Wales, Cardiff
The North Carolina Museum of Art, Raleigh
The Norton Simon Museum, Pasadena
The Sammlung Thyssen, Lausanne
The Barber Institute of Fine Arts, Birmingham
The Wadsworth Atheneum, Hartford
The Wallace Collection, London
Italian and other private collections

*Where not otherwise indicated, photographs
were provided by the museums or owners.*

ILLUSTRATIONS

COLOR PLATES

Canaletto's Life

Portrait of Canaletto
from a print by Visentini, 1735

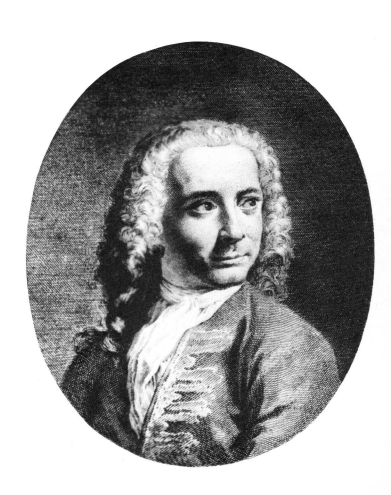

Antonio Canal was born in Venice on October 28, 1697, in San Lio (today it is Corte Perini, pop. 5484). His birth certificate is conserved in the Church of Santa Maria Formosa, and while it presents some doubts as to the precise day of his birth (which has also been read as October 17 or 18), it is quite clear in indicating his father as "Signor Bernardo Canal, painter," and his mother as Artemisia Barbieri. No titles of nobility are mentioned in this document, but it seems certain that the family was descended from the Canals, "original citizens" of Venice; this is confirmed several times by Canaletto himself and also by his use of the family coat of arms — a blue goat's head on a silver background.

We know that Bernardo Canal was a fairly well-known scenographic painter. He designed the sets for various musical works in Venice between 1716 and 1718 before moving to Rome. There is no doubt that Bernardo was the first teacher of Antonio, who began his career as a stage scenographer before the age of twenty. Opera librettos of the time show Antonio's name along with those of his father and his brother Cristoforo; we know nothing else of his brother after this period. Canaletto worked as his father's scenographic collaborator in Rome from 1719 to 1720. It was also during those years that the young Canaletto found himself in a new cultural ambience — that of the great eighteenth century landscape painters and *veduta* artists such as Van Wittel and Panini — and "solemnly excommunicated the theater," as he said later.

In fact Canaletto returned to Venice in 1720 and became a member of the Fraglia dei Pittori, thus assuming the position of an independent master. On March 8, 1722, Antonio signed his first contract, using for the first time the nickname, "Canaletto," by which he was destined to become internationally known. The contract was for a series of pictures commissioned by an eccentric En-

glishman, Owen McSwiney, who had failed as a theatrical impresario but was full of ideas, and who wanted to commemorate, with canvases representing imaginary funerary monuments, the greatest characters in recent English history. McSwiney was probably introduced to Canaletto by another man destined to play an essential part in the painter's career, the Englishman Joseph Smith. Smith was a unique character — banker, merchant, art collector, editor, but above all a man of society — in whose Venetian home visitors were introduced to the secrets of the city. In these early years, Canaletto and Smith established a relationship that surely was responsible for the majority of the painter's highly profitable English commissions.

We have little data from these years on the painter's life, though some light is shed on his personality and his art by the writings of his patrons and diarists. In fact already in the 1722 McSwiney contract we read that ''Canaletto is unsurpassed in painting things as his eye falls on them.'' A few years later a Veronese painter, who had commissioned four paintings for the merchant Stefano Conti (today in a private collection in Montreal), was informed that Canaletto ''amazes everyone here who sees his work, which is on the order of that of Carlevaris, but shines with the sunlight.'' In fact ''he paints from life and not at home from memory as Carlevaris does.'' Thus we see that from the very beginning of his career he was seen as a new artistic personality: an artist who painted Venice from life and not ''at home,'' as Canaletto believed Luca Carlevaris, his predecessor, had done.

This esthetic preference of Canaletto is not surprising, especially if we consider the historical background of the times — that of positivistic philosophy, initiated by the English. This was in fact the Age of Enlightenment, with the triumph of the French *Encyclopedie*, which was founded upon the rational knowledge of truth. Canaletto's artistic activity became very intense in the years 1725–30, during which time almost all of his works were commissioned by Englishmen and mostly before 1730. From this period came the twenty-four canvases for the Duke of Bedford, which today are in Woburn Abbey; the twenty canvases for the Duke of Buckingham, which later passed to the Harvey collection and were dispersed before some of them returned to Italy; the seventeen paintings for the Count of Carlisle; and many other minor groups of paintings. The preferred subjects of these pictures are always exterior views of Venetian architectural landscapes — the piazzas, canals, narrow streets, the Grand Canal, views of St. Mark's, and everything that attracted the increasingly infallible eye of Canaletto. He was also beginning to make use of apposite optical devices to better define the perspective precision of his views.

Canaletto was already a highly successful painter when he was in his thirties and early forties, as can be seen in other sources that give us a precise though indirect portrait of the artist. McSwiney,

writing to one of Canaletto's great patrons, the Duke of Richmond, stated: "He's a very difficult person, and changes his prices every day; and if one wants a picture from him, he should be very careful not to seem too anxious, because he risks losing out in terms both of price and quality. Canaletto has many more commissions than he should accept." Three years later McSwiney wrote to John Conduit: "He's a greedy and covetous man, and, being very famous, people are happy to pay him whatever he wants." At times, however, between the lines of these letters we can sense spite or anger on the writer's part for having failed to obtain a work by Canaletto. This is the case of the Swedish Count of Tessin, who visited Venice in 1736 and described Canaletto as avaricious, pretentious, and even something of a swindler. Joseph Smith, who became Canaletto's patron and agent — or at the very least his intermediary with wealthy foreigners who visited Venice, wrote: "This is not the first time that I have had to submit to the impertinence of a painter for my own interests or those of my friends."

From these documents we get an impression of Canaletto as a difficult person, yet we must take into consideration the particular cultural and economic situation in which he worked. After all he was a highly specialized artist whose patrons were a select group of rich traveling lords or their young scions who had come to Italy for an education: patrons who often, though they had a great deal of money to

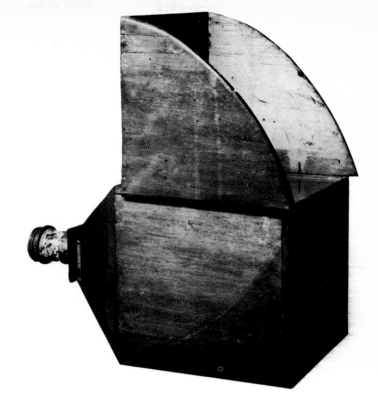

Portable Optical Chamber
Venice, Correr Museum

spend, had a tendency to spend as little as possible and to consider anyone a thief who expected to be paid, as Canaletto did for his work.

Beyond the few letters of travelers or of those who had acquired his paintings, we have little knowledge of Canaletto's life from 1735–40. Certainly this was the period of the flower of his production, not only for the great pictorial series but also for single works of an extremely high level, many of which were painted for Consul Smith. It was also on Smith's initiative that reproductions of pictures by Canaletto in Smith's own collection began to be published in a series of etch-

ings by Visentini. Fourteen were published in 1735, followed by two more sets of twelve each for a total of thirty-eight, which came to make up an entire volume that included Canaletto's most beautiful views of Venice. This volume came out in 1742 and was reprinted several times. Undoubtedly as a result of these reproductions, Canaletto's fame grew substantially, and as his work became more in demand its commercial value rose.

Around this time we find several Roman scenes dated 1742, clearly signed by Canaletto, five of which were painted for Smith. Scholars have wondered whether Canaletto went personally to Rome in 1742 and stayed there long enough to paint the works from life or whether he painted them entirely in his studio in Venice. The latter would have been possible, had Canaletto availed himself of the drawings that his nephew Bernardo Bellotto, who was a collaborator in his studio at that time, had made in Rome. There is no doubt that Canaletto possessed imitative abilities of such agility and perfection that he could have reproduced the triumphal arches and principal views of the Roman Forum merely from someone else's graphic description. And yet all this seems rather improbable, and many critics maintain that Canaletto indeed did make a trip to Rome in 1742.

A unique work by Canaletto dating from 1741–44 is the series of etchings he dedicated to Joseph Smith, who became the British Consul to Venice in 1744. The series consists of thirty-five magnificent etchings, most of which are of large dimensions, some "copied from life, others imagined," as the title indicates.

This distinction however is meant to indicate that among the prints of the series Canaletto at times chose real places for his subjects — views of locations near St. Mark's square in Venice — but that the majority of these views are idealized; that is to say, Canaletto modified them according to his own whims, taking only certain elements from life. This type of "whimsical" approach was in practice well before the time of Canaletto, who adopted the concept from the time of his earliest works. For example, idealized paintings of the tombs of famous English characters were his first success in the 1720s. But in the series of etchings, the distinction serves to clarify the painter's attitude toward reality.

If it is true that at the time of his artistic maturity Canaletto possessed optical and reproductive powers capable of rendering a perfect objective illusion of reality (such as in the views of real places), it is just as certain that his most intimate and secret vocation led him toward idealized representation (the view a capriccio). In fact we can almost always notice in Canaletto's "reality" a certain element of the artist's fantasy. It is precisely in that idealized portion of his works, which whimsically transforms reality into an artificial truth, that we find the culmination of Canaletto's art.

In the meantime toward the middle of the eighteenth century, political, economic, and social conditions in Venice rapidly

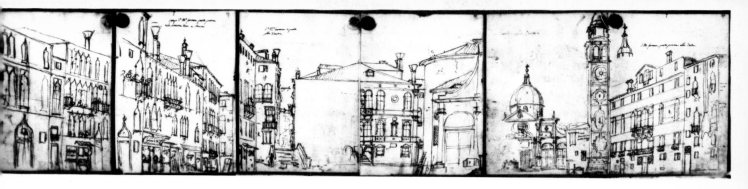

etches of Santa Maria Formosa
nice, Academy

worsened, above all on account of the great European wars of succession. In particular artists who were accustomed to selling their works to foreign travelers and tourists suffered, since tourism per force declined. We feel that Canaletto's decision to go to England was determined by these factors, in addition to his close ties with Smith and other English patrons for whom he had always continued to work.

Armed with a letter of presentation from Smith, Canaletto reached London in 1746 and began to paint for the Duke of Richmond. He remained in London until 1755, returning to Venice only for very brief periods, in order to carry out real estate transactions with the money he had earned in London.

Canaletto's stay in England was not easy for him, as is proven by his litigations with local artists who felt threatened by him. In fact, these English artists tried in every way to discredit Canaletto, even to the point of spreading the rumor that he was not the famous Canaletto, but rather

Canaletto's nephew Bellotto, who in reality at that time was wandering around Europe, having left Venice for good.

Canaletto reacted to these provocations by inserting advertisements in the *Daily Advertiser* of 1749 and 1751, publicly inviting art lovers to see him paint in his studio in Silver Street (which is today's Beak Street, near Regent Street in London). Despite these difficulties, Canaletto worked assiduously during these years, as the more than fifty large paintings that remained in the most famous English nobles' houses prove.

In 1755, upon his return to Venice, Canaletto found himself in a completely changed art market. As tourism increased with the improvement of political conditions in Europe, new artists had become active in the field of the *veduta*; in particular Francesco Guardi from that moment on was Canaletto's competitor and successor. This did not however prevent Canaletto from continuing to produce a vast output, as the numerous works from 1755–65 indi-

19

cate. By 1765 the Academy of Painting and Sculpture had finally accepted him as a member in the class of the Perspectivists, and Canaletto donated his *pièce de réception*, the *Architectural Perspective*, to them; it is now in the Venetian Academy. Canaletto's last precisely datable work is from 1766: a drawing now in Hamburg, with an inscription that states that it was executed "without eyeglasses" in the year 1766.

Canaletto died April 19, 1768. The inventory of his possessions reveals a much more modest economic condition than we would expect judging from the gossip of envious individuals and the artist's long activity, documented today by at least five hundred cataloged paintings. The greater part of his worldly possessions consisted of some real estate in the Scuola dei Luganegheri valued at 2150 ducats, which he left to his three sisters. Other than that, Canaletto had less than 300 ducats in cash, some furniture and jewels of little value, twenty-eight paintings in his studio, and a surprisingly modest wardrobe: four suits and four capes (three of which were quite worn), two old pairs of pants, two old jackets, and two old hats.

Venice in the Eighteenth Century

We have already noted on several occasions how Canaletto's life and activity were influenced by the life and times of eighteenth century Venice. At this point it might be useful to make a few general remarks about the historical and artistic situation of the city. From a political and economic point of view the eighteenth century was not a happy one for the city known as the republic of St. Mark, which in fact had clearly lost all of the extraordinary power that it had in the fifteenth and sixteenth centuries.

In the eighteenth century the storms that rocked European politics had a profound effect on Venice and threatened the very existence of the ancient republic; the city was deprived of the territorial and economic support that, especially with the rise of industrial development, was strengthening the great European powers. Thus Venice, now in an extreme phase that culminated in the French occupation of 1797, pursued a political line aimed mainly at survival, a policy that was clearly reflected in the socioeconomic situation.

Venice's sea routes had for the most part come under Turkish domination, and its importance as a port had been greatly diminished by the geographic discoveries that had shifted the mercantile traffic that had enriched her in the past outside of the Mediterranean and even more out of the Adriatic. Venice's great families, its financial and mercantile oligarchy that up to this point had formed the backbone of the thousand-year-old republic, saw the sources of their riches, which had always been linked to the sea, dry up.

All this however did not prevent Venice's cultural and artistic life from rivaling that of the greatest European centers such as Paris, Vienna, and London. Venice in fact was a profoundly free city, where reformed patricians could, within the limitations of censorship, express progressive social ideas; a city where the theater could glory in writers such as Carlo Gozzi and Goldoni; where jour-

nalism could boast of the great figures of Baretti and Gaspare Gozzi, two of the founders of modern journalism; where in more than ten operatic theaters the works of Baldassare Graluppi, Benedetto Marcello, Cimarosa, and the great Vivaldi resounded.

The visual arts as well flourished in this spiritually vital city. In fact despite Venice's financial difficulties, numerous new churches and palaces came to be built during this period: San Stae, I Gesuati, La Pietà, La Fava, and the church of San Marcuola displayed their elegant grace in a style that was between Rococo and Neoclassical.

The new palaces demonstrated the extreme ambitions of the great Venetian families: the Rezzonico and Pesaro palaces, carried out and detailed with the greatest splendor; the Pisani palace, built by the great family of Doges who had also built a villa in Stra; the Labia palace, which would be decorated by Tiepolo; the Surian, Albrizzi, and Savorgnan palaces; and others besides.

If the face of the city was changed and enriched from an architectural point of view, progress in the field of painting was no less important. In fact Venice, along with Paris, was the seat of the greatest creations in European painting of the eighteenth century. At the time of the development of the Rococo style in France during the reign of Louis XIV and Louis XV, which saw the rise of painters such as Watteau and Boucher, Venice produced Sebastiano Ricci and Antonio Pellegrini. These two traveling painters carried from Italy to England and later to all of Europe (by way of Holland and Germany, Paris and Austria) the mastery of a luminous, airy, fresh approach to painting that was unparalleled in its festive, scintillating use of color. The greatest of all the Venetian decorative painters was Giovanni Battista Tiepolo, the most celebrated in Europe. He was active not only in Italy but in Germany, where he decorated the Prince's residence in Wurzburg with frescoes, and in Spain as well, where at the end of his career, between 1762 and 1770, he decorated the Royal Palace in Madrid.

At the same time as this triumphal period in eighteenth century decoration, which dominated the entire first half of the century, there developed another group of artists, linked to the esthetics of Neoclassicism. Sensistic philosophy, particularly that of the English philosophers, and the French philosophy of the Age of Enlightenment led to esthetic concepts that sought to attain Truth or a moral scope in art. In France this produced the supreme realism of Chardin, the great pastel masters such as La Tour, Perronneau, and Liotard — all of which led up to Greuze, a true product of Diderot's moralistic theories. In Venice the reflection of this realist culture came to manifest itself above all in the genre and portrait painters and in the landscape and *veduta* artists.

In the field of genre painting Venice could boast of Pietro Longhi, who with his innumerable gallery of family portraits set in the interiors of Venetian

houses, bears comparison with the acute, piercing, at times satirical work of the great English painter Hogarth and his poetics of the "conversation piece."

Venice surpassed all of Europe in the field of landscape painting as well. At the beginning of the century Marco Ricci seemed to renew the solemn beauty of the fifteenth century landscape, following the examples of Titian and Bassano, in both his paintings and his series of magnificent engravings. But the field in which Venice held a unique position — and we return here to Canaletto — was that of the architectural view, that is to say, the representation of beautiful Venetian monuments. This certainly was not a new field of painting — Venice had precursors in the fifteenth century works of Gentile Bellini and Carpaccio, in the prints of the great traveling Germanic engravers such as Reeuwich, and in the perspective view of Jacopo de Barbari.

At the end of the seventeenth century Venice had also directly experienced a returning wave of international *vedutismo:* in particular toward the turn of the century it had hosted the Dutch painter Gaspar Van Wittel, who did several works representing Venetian locales. At that time Van Wittel was surely an inspiration and model for the better-known Luca Carlevaris, the Friulan painter whom Canaletto derided, accusing him of painting at home and not from life. It is doubtful however that Canaletto's accusations were entirely based upon truth, since Carlevaris' views have a documentary precision and incisiveness that seem to reflect careful study from life; and Carlevaris' numerous preparatory drawings seem to bear this out. Carlevaris was much more successful than the Dutch painters in capturing the essence of Venetian life, though perhaps emphasizing its more ordinary and less original elements. This feature may account at least in part for Canaletto's criticism; to paint "at home" for Canaletto perhaps meant to paint with little fantasy. Canaletto on the other hand sought to capture certain details from real life — the quality of light expressed by the "picturesque accidents" (as he himself would later call them) that characterized his work.

As we have seen, the world of eighteenth century Venetian culture and art was extraordinarily active and vital, and it was in this atmosphere that Canaletto worked. We will now trace his main works in their chronological development, from about 1720 to 1768.

Canaletto's Works

The fact that Canaletto had begun his career as a scenographer is evident in his earliest works. In fact, if we consider the *Tombs* of the great Englishmen painted for McSwiney, and especially if we examine the *Fantastic Tomb of Lord Somers* (Plate 2), we find several specific elements of Bibiena's "angular perspective," at that time a traditional theatrical element and one that Bernardo Canal certainly had taught his son. The Roman ruins in this painting consist of gigantic arcades that act as a background, with two huge pilasters flanking the tomb; below flow the waters of a fountain. The illusionistic composition is like a painted theatrical backdrop, and there is no doubt that it is linked to Canaletto's experience as a scenographer.

This same scenographic quality can be found in another group of early paintings that have recently been attributed to Canaletto. This series is dispersed in various private collections: two, for example, now in private collections in Venice, represent *Roman Ruins* (such as the one in Plate 1) in scenographic perspective, animated by numerous small human figures.

Undoubtedly paintings in the style of Salvator Rosa and Claude Lorrain, which the young Canaletto had the opportunity of seeing in Roman collections, could have influenced this type of composition. We can also see an echo of the early paintings of Panini, who was active in Rome from the 1720s on, in which we find similar architectural ruins. But Canaletto's color intonation is entirely original — browns dense and fiery, one is tempted to say romantic — and is closer to Marco Ricci's canvases of similar landscapes and ruins than to Rosa or Lorrain.

Thus Canaletto seems to belong to the best-known Venetian tradition, based on pictorial effects of color and light, rather than on the topographically faithful representation characteristic of the Roman painters of ruins. Canaletto returned to this "romantic" approach in the four views painted for Stefano Conti of Lucca that are now in a private collection in Montreal. We see in these works a certain scenographic exaggeration in the flanking architectural elements like the wings of a stage, and the accelerated perspective of buildings set in strong counterpoint by light on shadow beneath wide expanses of blue sky.

There is an extremely interesting preparatory sketch in the Ashmolean Museum in Oxford (Plate 3) for the *Rialto Bridge* from the group of paintings for Stefano Conti. This drawing contains an annotation about "the sun," that is, the zone of the picture where the reflections of light appear strongest and most dazzling. This flash of light is precisely transferred to the painting, showing how Canaletto would choose an element from reality, go to the actual location to make drawings, and note from life the effect of the "pictorial accident" — in this case, the sunlight — in order to later reconstruct this effect within the scenographic framework he had inherited from Venetian tradition and from his own specific experience in the theater.

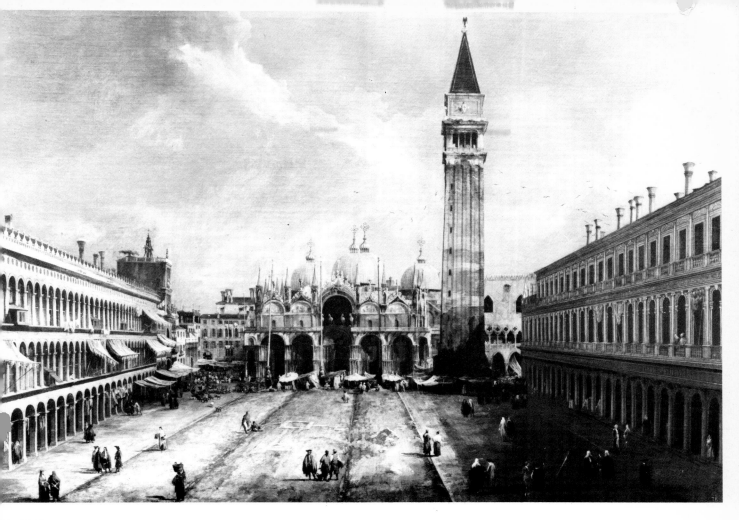

Mark's Square

sanne, Thyssen Collection

These same effects of sunlight and shadow, and the same almost romantic approach to light are found in the four paintings formerly in Liechtenstein, some of which are now in a private collection in Milan. Among them is one of *The Grand Canal* (Plate 5), with the Rialto Bridge in the background as seen from Ca' Foscari, which is characterized by a particular play of light that is so artificial as to make one wonder whether Canaletto did not use two sources of light instead of one. Here again the scenographic element of the "pictorial accident" prevails over a mere reproduction of reality.

Among Canaletto's most beautiful early works are some of the first pictures he painted for Joseph Smith between 1728 and 1730, particulary several large-scale views of St. Mark's Square, which later passed with the rest of Smith's collection to Windsor. *The Clocktower Seen from the Piazzetta* (Plate 6) uses — like the wings of a stage — the Procuratie and the Belltower on one side, and St. Theodore's column and the basilica itself on the other in a highly accelerated perspective view ending in the Clocktower, all beneath an expanse of sky transversed with gauzy clouds. The human figures are particularly large and painted in lively colors: a nobleman in black and a senator in red are in the extreme foreground.

This use of lively human figures is typical of Canaletto while he was under the influence of the works of Marco Ricci, who used such figures as elements to define the extent of the luminous space and to emphasize the diminishing effect of color in the distance.

Another extraordinary work from this early period is *St. Mark's Basin* (Plate 7) seen from the Giudecca, now in the National Museum of Wales. Here too in the extreme foreground we see a couple — a gentleman in black and a lady in reddish-orange — who are walking out of the area of shade into the full sunlight: the light grazes their heads, producing an effect of dynamic animation that is new and profoundly expressive.

Other great and well-known works by Canaletto date from the 1730s, such as *The Stonecutter's Yard* in the National Gallery in London (Plate 8). This painting — which has a particularly monumental quality — depicts one of eighteenth century Venice's most picturesque locations, Campo San Vidal. Before a bridge was built there during the Austrian occupation, there was a huge stonecutter's yard where parapets for wells, capitals, and columns were prepared under the blazing sun. Beyond the stonecutter's yard we see the Grand Canal, with its slate-colored waters, the church of the Carità with its ancient belltower (which later collapsed), and the Scuola della Carità, which was later given a neoclassical facade (now the Academy Galleries). The contrast between the shady areas and those illuminated by the sun is very strong, as is the lively use of brilliant colors in the human figures in the foreground and at the balconies, in the cur-

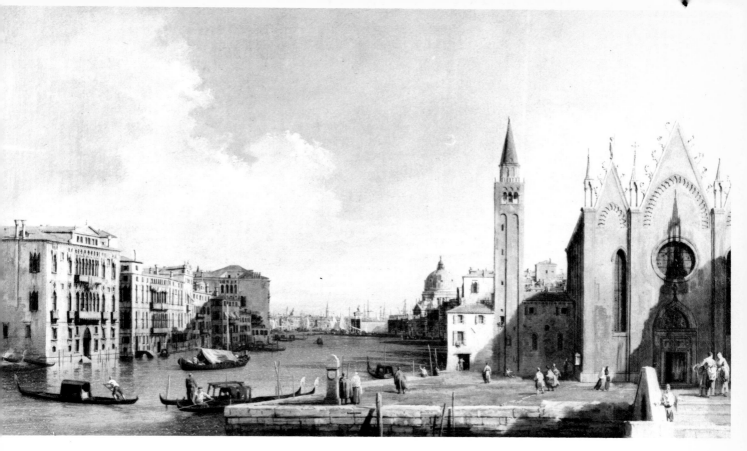

ew of the Grand Canal
ward the Carità
indsor, Royal Collection

tains, and in the laundry hung out to dry. The light that passes over the white pinnacles atop the facades of the churches or the distant belltower of San Trovaso gives an extraordinary animation to the pictorial space — a space that is much more real because we see it "shine with the sunlight" as Marchesini said in 1726; but it is also an imaginary space created by the infallible eye of the artist who used every possible element to emphasize his most pure and abstract pictorial values.

Another magnificently solemn composition is the *Flour Warehouse* (Plate 9) in the Giustiniani collection in Venice. The view here is of the last stretch of the Molo embankment, which terminates at the building that later became the seat of the Academy of Painters and Sculptors (and subsequently the Port Authority). Canaletto has managed here to depict not only the warehouse and the Giustinian Palace behind it but also, on the left, a view from the Customs House at Santa Maria della Salute, full of docked ships and pedestrians on the embankment, among whom are some Orientals near the boats. The composition has a horizontal movement, with a very broad, almost wide-angle perspective, which Canaletto often used from this time on to lend a credibility and at the same time an imposing monumentality to his compositions. Here the human figures, as in Canaletto's works from the preceding decade, are of noteworthy proportions and play an important part in this canvas; they seem to clearly reflect Ricci in their animated poses and lively colors. Bright red caps, white turbans, blue capes, and silver shawls constitute the brilliant points of contrast that punctuate the spatial dimensions, giving it a precise dynamic feeling. This work slightly predates two other magnificent Canaletto canvases (formerly at Farnborough Hall), *The Entrance to the Grand Canal* and *The Piazzetta*. The color in these works takes on a translucent effervescence, almost like Chinese jade.

Along with these works from around 1730 the early phase of Canaletto's career comes to a close with the great series, the first of which is probably the group of twenty-four views painted for the Duke of Bedford. Several preparatory drawings for these works have survived (Plate 10) in one of Canaletto's notebooks (today in the Academy), which for various reasons can be dated between 1728 and 1730.

This was a crucial moment in Canaletto's career because it marked a singular change in his use of color and in the character of his palette: in fact his colors are suddenly much more luminous and tend to become transparent, where before they were dark and smoky, deliberately dramatic. The romantic approach that Canaletto had inherited from Ricci and that had been so typical of his early works is suddenly banished in the Bedford series and in his subsequent paintings of the fourth decade of the century. The intonation takes on clear, bright transparencies, akin to those of the Dutch palettes. It would almost seem that

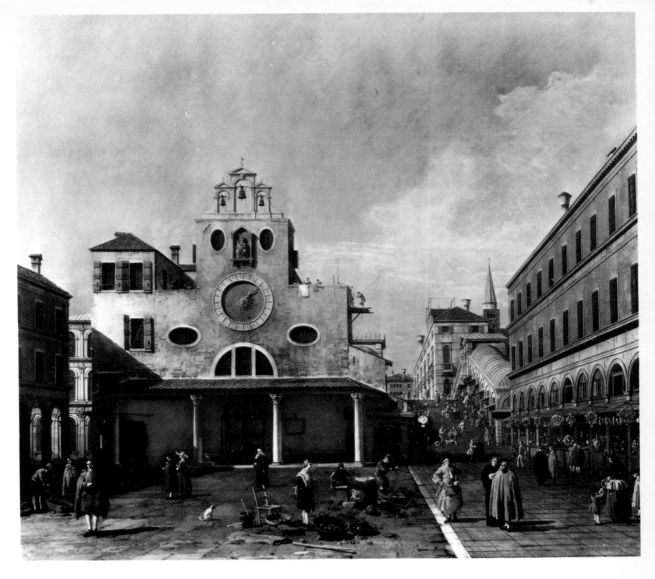

Campo San Giacometto
Ottawa, National Gallery of Canada

Canaletto was experiencing a renewed influence of Van Wittel or even Carlevaris or at any rate of Dutch painters then known in Venice.

We feel that this stylistic change could also have been brought about by specific requests from Smith or other patrons, who favored the Dutch style. With the fame of Dutch masters of the late seventeenth and early eighteenth century such as Berckheyde and Van der Heyden so widespread, Canaletto's patrons might have expressly requested a different intonation, clearer and more luminous, perhaps more serene, in his views of Venice. And there is no reason to believe that he would have refused a request that fit so closely the natural evolution of his pictorial style. In fact two magnificent views of Venice, which today are in a private collection in Milan, *The Reception of the Imperial Ambassador* (Plate 12) and *The Return of the Bucentaur*, reflect this new, extraordinarily lively conception of color and at the same time inaugurate a series of themes that continued during the fourth decade of the century: ceremonies, celebrations, public gatherings, and decorations for special occasions in the Venetian life of the times.

The reception of the imperial ambassador at the Doge's Palace, the sujbect of the first painting, took place in 1729. We see the ambassador, dressed in black with a long wig, as he is received by the Venetian senators in scarlet robes, by the judges in violet and turquoise, by the Doge's gentlemen in their lively red and silver striped costumes. In the foreground in the calm waters of the canal next to the Doge's Palace are moored the three gilded gondolas of the ambassador's party, of the papal representative, and of the ambassador of France, all decorated with allegorical sculptures; the gondoliers wear the magnificent costumes of a style between Venetian and Chinese that was so popular in eighteenth century Europe. Thus this scene offers the most lively, luminous, stupendously chromatic view imaginable. The related canvas, the *Return of the Bucentaur*, is perhaps even more magnificently rich in chromatic effects. We also find Canaletto's new style in a third, truly extraordinary work, dating from perhaps a little later, representing a *Regatta on the Grand Canal* (Plate 13), now in the National Gallery in London. This canvas depicts the passage of the gondolas of the regatta in front of Ca' Foscari, "where the Canal turns"; in the distance we can make out the Rialto Bridge. If we call to mind Canaletto's handling of a similar perspective angle in the 1723 Liechtenstein canvas (Plate 5), with its dark, dramatic, scenographic treatment of shadows, and compare it with this canvas of at least ten years later, we can gauge how far Canaletto had come in his increasingly luminous and clear conception of "air" — as he himself defined atmospheric transparencies — which he was able to accentuate, with an amazingly light touch, producing a myriad of pictorial effects.

Another great Venetian celebration was the Doge's annual visit to the church of

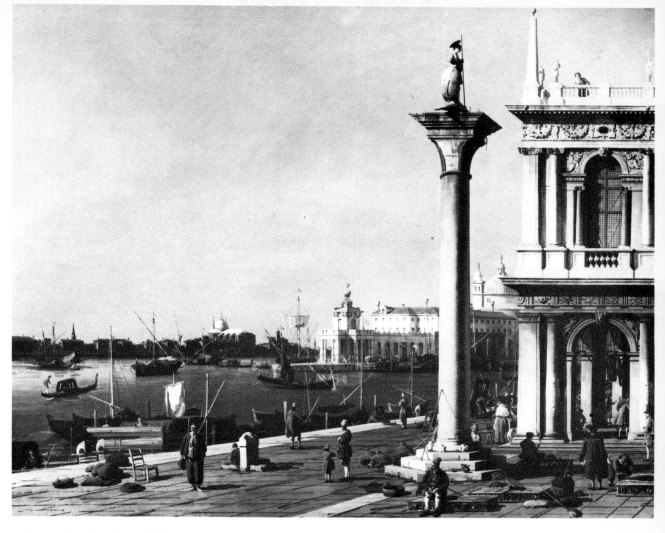

St. Mark's Bay Seen from the Piazzetta
New York, E. V. Thaw and Co.

St. Rocco on the saint's feast day, August 16. According to tradition the Doge would proceed flanked by two wings of senators and townspeople; works by Venetian painters were exhibited outside the Confraternity of St. Rocco, as a sign of celebration and for the admiration of the multitudes. In a canvas now in the National Gallery in London (Plate 14) Canaletto depicts all this with such incisive precision that several of the paintings on exhibit can be identified: one perhaps by Tiepolo, one by Piazzetta, landscapes in the style of Ricci, and even one — the first on the right — that could be a view by Canaletto himself.

At times Canaletto captures the animation of Venetian eighteenth century life in its normal daily course of events. Such is the case of another masterpiece in a private collection in Rome, *The Wharf and the Old Library* (Plate 15), which depicts a site that in Canaletto's time was also a fishmarket. In perspective on the right are Sansovino's buildings, and in back of them are the wheat and flour warehouses; at the left, on the other side of the canal, are the church of Santa Maria della Salute and the bay. The group of docked gondolas with their silver trimmings, the crowd of buyers and sellers at the fishmarket, the gentlemen out to take the sun, to chat, and to observe the beauties of Venice all contribute to making this painting one of Canaletto's most noteworthy creations.

A similar view of the warehouses (yet from a much closer vantage point) with the Salute in the background is *The Entrance to the Grand Canal* in the National Gallery in London (Plate 16). This extremely limpid work, in which the domes of the Salute look like magnificent mother-of-pearl shells gleaming in the morning light and the mirror-like water reflects the boats with their banner-like sails, also dates from the fourth decade of the century, which was a particularly rich and active period in Canaletto's career.

A *pendant* to these last two paintings is another work in the National Gallery in Washington, which is a similar view of *St. Mark's Square toward the Southeast* (Plate 17). Canaletto often returned to views of the square, and on this occasion he gives us a broadened view of it, so wide in fact as to include the entire facades of the Doge's Palace and the basilica, in an obvious device of perspective distortion.

(We will clarify later how Canaletto was able to arrive at these combined views, inaccessible to the human eye, by using a special device, the "optical chamber," which made it possible for an artist to obtain a faithful image of reality, reduced to the format necessary for drawing on a sheet of paper.)

The poetic quality of this canvas consists above all in the liveliness of its numerous details: groups of gentlemen conversing in the foreground, behind them the cloth vendors, and on the right, below the Belltower, the silversmiths. Beneath the Doge's Palace, a priest on a platform is preaching to a crowd of people, some of whom are more attentive than others.

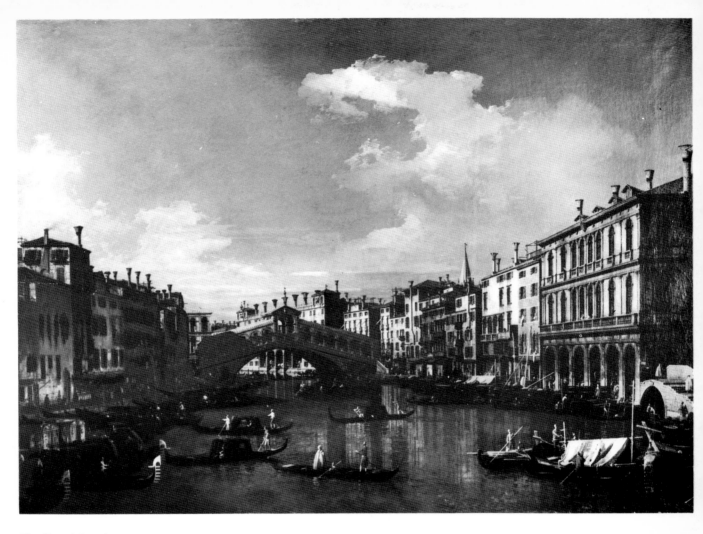

The Grand Canal
Seen from the Rialto Bridge
Rome, National Gallery of Ancient Art

The whole enchanting vista of St. Mark's Square is depicted with such extraordinary skill that it is easy to understand how such works would elicit the greatest enthusiasm in foreign visitors who came to enjoy the captivating beauty of Venice.

We have mentioned Canaletto's method of using the optical chamber for wide-angle views of the two works in Washington; this same device was used in two other magnificent works of the late 1730s or very early 1740s, one now in Boston and the other in London.

The Bay of St. Mark's in the Boston Museum of Fine Arts (Plate 19) is apparently depicted from the vantage point of the Customs House Promontory, but here too perspective distortion has included in the picture a view that today would be possible only with the use of a wide-angle camera lens. The island of San Giorgio, in fact, appears to be near the center of the bay, in order to create a sense of balance with the Doge's Palace and St. Mark's on the extreme left. The broad expanse of water is punctuated with foreign and Venetian vessels, gondolas, and small boats, as if to convey the spirited life that pervaded the entire city. This view is characterized by the light of sundown, coming from the West, which strikes the masts and sails of the innumerable vessels riding at anchor, so that the vertical elements of the picture gleam like the stalks of bamboo in one of those marvelous Chinese paintings in which the material itself seems to shine with its own mysterious life. Thus Canaletto's abstract use of light creates an extremely poetic effect that surpasses real life.

The Bay of St. Mark's As Seen From San Giorgio (Plate 20), a canvas in the Wallace Collection, is similar in view, proportions, and wide-angle perspective. On the left we have the Giudecca Canal, the dome of the Salute, the Customs House with its golden ball, and the embankment of St. Mark's with the warehouses, the Mint, the Library, the square, and the Doge's Palace. In the foreground are boats, human figures, ships with their colors in the wind: we can see the Dutch and English flags, as well as banners with the lion of St. Mark. This horizontally extended view, like the related work in Boston, suggests a particularly majestic expression of the myth of Venice as portrayed throughout her long history.

Several graphic works of an extraordinary quality belong to this same period, which was certainly one of the greatest in Canaletto's career. Canaletto's drawings fall into two general categories: those done in preparation for paintings, like the ones in the album in the Academy in Venice, and his finished drawings, made to be sold to collectors. Many of the latter ended up in the hands of Smith, the majority of which, numbering almost 150, he sold to the King of England, who took them to Windsor where they are today.

Many of these drawings depict the banks of the Grand Canal, with its rows of houses animated by human figures and gondolas. But perhaps the most extraordinary of these drawings are four views

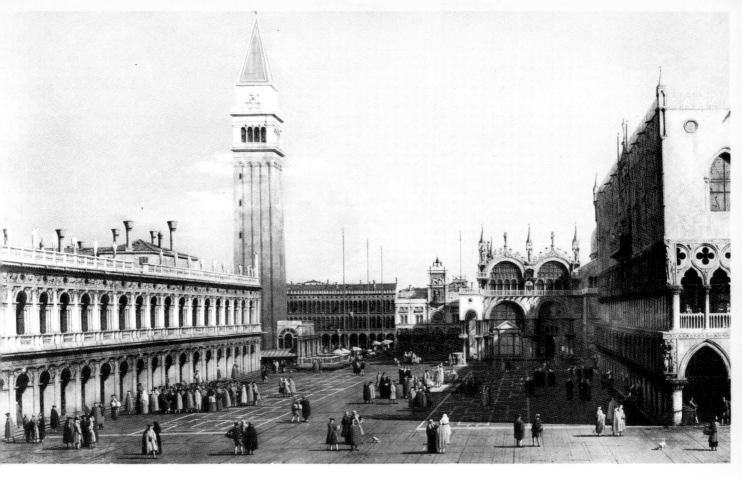

View of the Piazzetta Toward the North
asadena, Norton Simon Museum

of the lagoons, which bear comparison with Canaletto's great panoramic views, now in Boston and in the Wallace Collection, that date from the 1740s.

Two of these views are taken from an unusual vantage point, the *Motta di Sant'Antonio* (Plate 22), an area of dunes near the actual location of the Public Gardens and the pavilions of the Biennale. In the first sheet Canaletto looks toward the quay, depicting the infinite row of houses and palaces stretching all the way to St. Mark's, the Salute, and the Giudecca. In the foreground are ships waiting to be repaired, passing gondolas and boats, and fishermen intent on their work. In the second sheet, turning to the right from the same vantage point, Canaletto depicts the churches of San Giuseppe di Castello, Sant'Anna, the profile of the cathedral of San Pietro, the distant Castello quarter, and finally, the mountains of the mainland, at the outer limit of the lagoon.

These two views together provide an evocative panoramic view from an unusual vantage point, expressed through a luminous clarity of a highly poetic quality. No mere objectivity hampers the lyrical quality of these drawings, despite their objective precision: instead, they are dominated by the profound evocativeness of the wide-angle distortion, which gives them an almost magical air, stretching the boundaries of the horizon beyond any defined limit.

The other pair of drawings depicts *The Island of Sant' Elena* (Plate 23), which is located in the solitary lagoons between Castello, the Lido, the Charterhouse, and the port of Sant'Andrea. We can almost hear the reeds rasping in the wind and the cries of the seagulls. Earth and water meet at the edge of the dead lagoon in a strip that becomes almost entirely white: here white is expressively treated as a color. The mark of Canaletto's pen is lyrical yet incisive, bringing to mind the technique of drypoint.

So we see that often for Canaletto a drawing assumes a quality of almost sentimental lyricism, a more intimate poetic quality than that of his paintings; and in his drawings we find some of the most intense manifestations of his creativity. But Canaletto also achieved this magical quality in his engravings and etchings, particularly the series of thirty-eight works published in 1744 on the occasion of Smith's appointment as British Consul. These represent not only the greatest masterpieces in all of eighteenth century European engraving, but perhaps Canaletto's greatest masterpieces as well. In these works Canaletto seemed to totally eliminate the restrictive necessity of adhering to an objective recreation of reality; the number of views from life is extremely small, while those *a capriccio* predominate. Thus Canaletto was able to express to the highest degree his mastery of luminous effects in their most pure, formal beauty.

Modern scholars have concurred on dating these prints from about 1741 to 1744. They have also pointed out that Canaletto, in some of his later engravings such as the *Marghera Tower* (Plate 24) or the

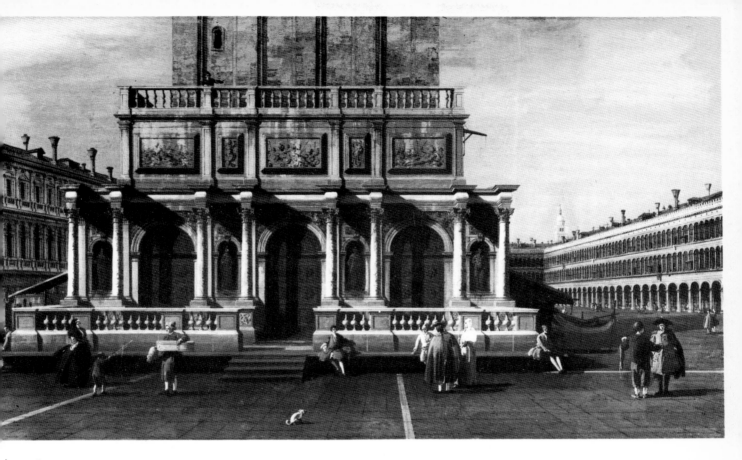

Loggetta
~~~ingham, *Barber Institute*

equally famous *Portico with Lantern*, succeeded in creating images in which the representation of reality was surpassed, while the line took on a highly lyrical quality: tremulous, thin, often resembling the stroke of a pen yet availing itself of all the expressiveness of the etching; certain areas are left completely untouched, in order to suggest more dazzling effects of sunlight.

The lagoon near the Marghera Tower — an isolated shore barely touched by the softly rippling waves — is unforgettably depicted by Canaletto. Silvery little clouds float in the sky above the mountains, in an atmosphere that seems to have been washed by a sudden rain: these clouds express a degree of formal freedom that Canaletto would never again attain, not even in his greatest paintings.

We have seen what an extraordinary importance technique had in Canaletto's drawings and engravings. His graphic technique was only an apparently simple one: black or red chalk, generally gone over with pen and ink for drawings to be sold to collectors, and rarely brushed over with washes. He preferred to use white paper to emphasize his constant search for luminous effects. The inks were iron based and turned a blackish brown; rarely he used India ink or sepia, and it is limited mostly to shaded areas and applied with a brush. Even though Canaletto drew freehand, we can often detect traces of chalk or a drawing pen in the architectural views. At times too the arches are drawn with a compass, but all of this is always gone over with a nervous line that restores a feeling of originality to every mechanical method.

Canaletto's working method was very interesting: he would begin with "documentary" sketches (most of which are in a notebook or loose sheets in the Academy in Venice, while others are in the Miotto Collection in Udine). The loose sheets were originally pages of notebooks — Canaletto used to make drawings in the field in preparation for his canvases. These sketches are generally chalk, gone over later with ink.

Scholars have discussed the question of whether these chalk sketches were done with the aid of an optical chamber. This reflecting optical device projects a reduced image either vertically onto a sheet of paper spread on a table or onto a frosted pane of glass in the portable type of model that Canaletto probably used.

Several original optical chambers have survived, and Canaletto surely used them, as his biographers make clear. But the problem is how did he use them? Zanetti, writing in 1771, stated that Canaletto knew how to use the optical chamber, "eliminating its defects." This means that the use of such a device is not mechanical, as it would be for an amateur (and in fact these instruments were invented for the use of amateurs), but subject to the creativity of the artist, who used it for his own special purposes. Thus it would be an error to exaggerate the importance of Canaletto's use of this device in the preparation of his drawings

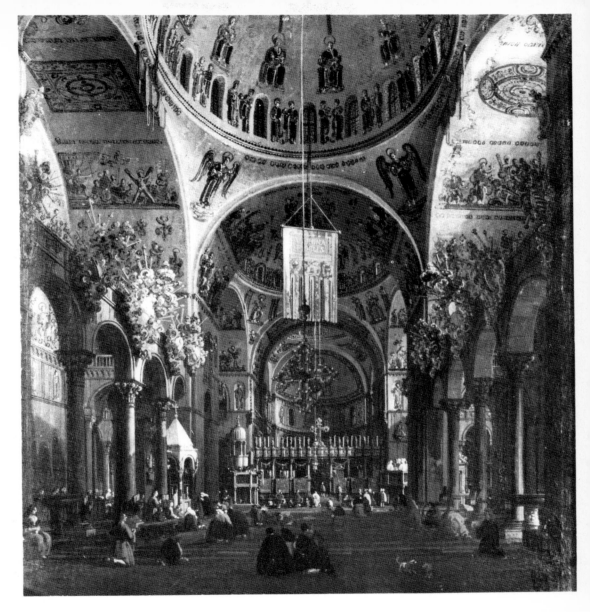

St. Mark's Basilica
*Windsor, Royal Collection*

and paintings, even though he clearly almost always used it.

From the notebook of sketches made in the field, with the aid at times of the optical chamber in order to obtain more precise perspective volumes or to create particular effects using special telescopic or wide-angle lenses, Canaletto would proceed to elaborate the drawing to a point where it resembled the finished drawings done for collectors; the next step was the painting itself.

This process is fully documented in the notebook in the Academy, where six sheets of drawings correspond to the view of *Campo Santa Maria Formosa* (Plate 11) in Woburn Abbey. In these sheets we find precise indications regarding color, light, the sun, and the areas of white that correspond to the finished painting.

Thus it is evident that Canaletto took into consideration the notes he made in the field, in order to give a faithful representation of details; nor was there any reason why he shouldn't have done so. But the recomposition of the whole was his work and his alone: in fact, he would artificially modify the perspective in order to achieve the desired effects. Thus we have a series of "impossible views, in which the use of the optical chamber, instead of serving to adhere more closely to reality, provided the artist with a tool for abstraction, permitting him to distort perspective as he wished and to compose views different from those dictated by reality.

A perfect example of this perspective is the view of *St. Mark's Square* as seen from the Clocktower (Plate 26), now in Hartford, which includes in a single view of St. Mark's and the Procuratie Vecchie, which in reality are next to the tower itself. Thus the view is almost circular, like those obtained today with "fish-eye" lenses. Forcing perspective in this way allowed Canaletto to depict what not even the human eye could see, but what his "enlightened" mind enabled him to construct. Thus it is clear that Canaletto's creation of "impossible views" found precise support in the esthetics of his time, of which he was most certainly aware.

For other works, Canaletto devised scenes with multiple points of view. As a recent study has pointed out, there are views such as the one of *The Church of the SS. Apostoli* in the Alemagna Collection, in which a typical Venetian square is artificially constructed to be seen from three different places. The human eye, observing from a single vantage point, would require that all the lines of perspective converge in a single vanishing point.

Thus Canaletto's depiction of reality is more illusory than real, more constructed and modified than merely seen and reproduced. This does nothing to diminish the extremely evocative quality of Canaletto's images, which capture the true light of Venice, its true atmosphere, its real situations and monuments. But Canaletto recomposed and readapted all these elements to his own conception of the finished picture, whether he wanted

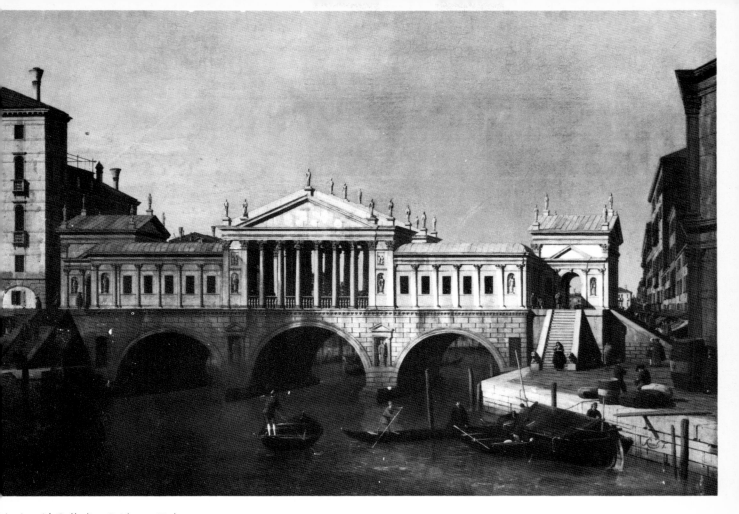

*riccio* with Palladian Bridge at Rialto
*dsor, Royal Collection*

it to be wider or more narrow, closer or farther away, in order to produce a determined effect with his "picturesque accidents."

We have previously alluded to the theory that Canaletto had gone to Rome in 1742. In fact several of the large *Views of Rome* now at Windsor, and originally in Smith's collection, bear the artist's signature and the date 1742. The historical and stylistic question of whether Canaletto went to Rome or not that year is difficult to resolve. We know that Canaletto had been in Rome when he was in his early twenties, but it is difficult to attribute works painted twenty years later to memories of that stay in Rome; surely Canaletto's graphic and pictorial methods then were quite different from those of 1742, when he did the paintings for Smith. In fact these pictures have a monumental conception and a scenographic grandeur that imply a direct study from life, thus making a trip to Rome by Canaletto in that year seem highly plausible. It is certain that Canaletto's nephew Bernardo Bellotto was in Rome in 1742, and we will take this opportunity to briefly discuss this unique and important figure in eighteenth century Venetian *vedutismo*.

Bernardo Bellotto was the son of Canaletto's sister and had been his collaborator from 1738 to 1743. According to contemporary biographers (see the Orlandi-Guarienti Dictionary of 1753) the essential, unique characteristic of the young Bellotto's art was the fact that he could imitate his uncle's style to such a degree as to make his works indistinguishable from those of the master, so that even experts were fooled.

This is why many scholars feel that it is plausible that Canaletto could have used Bellotto as an "alter ego," in order to paint pictures of places in Rome that he had not actually seen (or seen again). All this presents a problem that is just as impossible to solve now as it was impossible for Canaletto's and Bellotto's contemporaries to tell their pictures apart. In fact only recently a series of works believed to be by Canaletto were reattributed to Bellotto; they are in fact expert fakes of works by Canaletto. Two of these works are in the National Gallery in Ottowa and depict views of *St. Mark's Square* and *The Arsenal;* two others are in the Mills collection in England.

In fact in 1734 the association between Canaletto and Bellotto was irrevocably broken off. There was certainly a dispute between the two artists, since when Canaletto was in England, Vertue recalled that there had been a serious disagreement between uncle and nephew, possibly on account of Bellotto's imitations of his uncle's pictures. It is not difficult to imagine that Canaletto would be angry at seeing his works so skillfully copied as to be mistaken for originals. And the possiblity that Bellotto's character was such that he would take advantage of this situation is borne out by the fact that after leaving Canaletto's studio never to return to Venice (he went first to Lombardy, then was in Piedmont until 1745, then Vienna, Munich, Dresden,

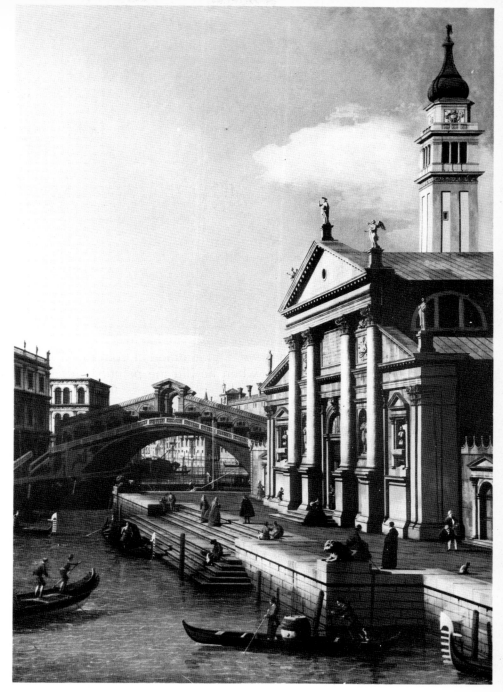

*Capriccio* with the Rialto Bridge
*Raleigh, North Carolina Museum of Art*

and finally Warsaw), he continued to sign his paintings "Bernardo Bellotto, called Canaletto," thus usurping the nickname that was exclusively his uncle's.

If a visit by Canaletto to Rome in 1742 is doubtful, his stay in England between 1746 and 1755 is fully documented. Canaletto was away from Venice for nine years (with a few brief return trips), nine years in which he concentrated all his productive activity in London and its environs, in the various noble houses where he was called to paint.

Painting in England posed an esthetic problem for Canaletto, especially with regard to the natural settings he encountered in that country. He had left Venice after completing his major "wide-angle" compositions. And it is certain that London — in contrast to the intimate, limited, minute views of Venice — with the wide arc of the Thames and the limitless country vistas, provided the artist with a wide frame with practically no boundaries in which to paint, a situation that might have created serious artistic problems for him.

But Canaletto had no such problems in England; in fact he easily applied the compositional concepts with which he had experimented in Venice to the English setting. He also adjusted his palette with surprising ease to the British landscape and its predominating colors — the green of the fields or the brick red or purplish color of the buildings — which were so different from the colors he had used in Venice. But this goes to prove

Canaletto's strong link to the reality he saw, despite his tendency at times to evade reality by means of formal abstraction. In fact many of his works document his singular attention to all the new chromatic effects with which he experimented in England. These amounted to about fifty paintings and thirty drawings, which are not limited to views of London. Although he could have easily dealt with the Thames as he had dealt with the waters of Venice, instead he often depicted views outside the city. For example, the crumbling, almost spectral walls of *Alnwick Castle* in the collection of the Duke of Northumberland or the massive, turreted forms of *Warwick Castle* that appear in the painting formerly in the collection of the Earl of Warwick and in the drawing of the same castle in the Lehman collection.

In other cases Canaletto succeeded in evoking the lyrical quality of the English countryside in the melancholy greens of the damp fields of Badminton, or in the spectral, silvery light reflected by the clouds over *Walton Bridge* (Plate 33) in the Dulwich Gallery, painted in 1754.

Certain scholars have maintained that Canaletto's English works are of an inferior quality. It has been said that his works of this period are too detailed and rambling, his draftsmanship too fussy and artificial, his colors do not correspond to real colors, and his palette is cold and gray. None of these assertions are true.

If we examine the extraordinary view of *The Thames Toward Westminster Bridge*

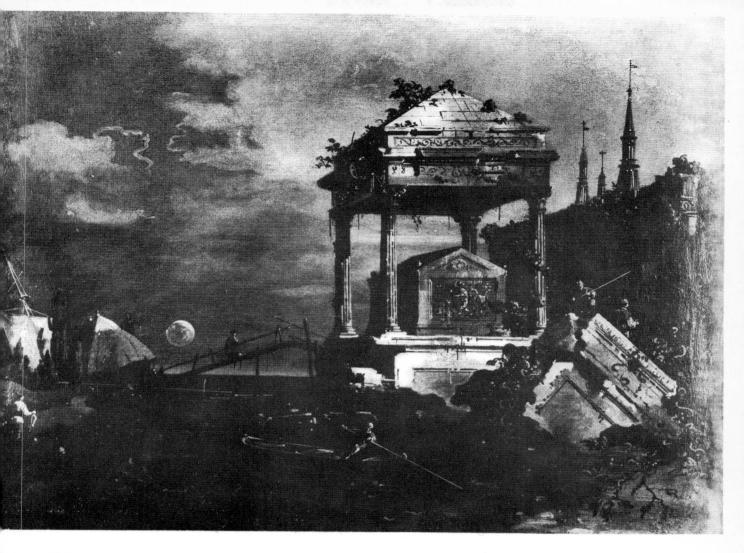

*...riccio* with Tomb
*...rence, Uffizi Galleries*

(Plate 30) in the National Gallery of Prague, we see a vivacity of draftsmanship and an incisiveness of color worthy of Canaletto's great Venetian works of the 1740s. The red of the bricks of the buildings, the blue of the sky, the gray of the cathedrals, the dazzling white of Westminster Bridge, and the green Thames ploughed by a myriad of ships are neither flat nor tired; nor can the famous green of *Badminton Park* (Plate 31) be taken as an example of a fussy or affected painting — on the contrary, it is all the more authentic where the sheep make white spots on the emerald green of the grass, while the carriages with their splendid horses parade in the foreground, against the backdrop of the small neoclassical temples placed at the edge of the lawn. These details testify to the efficacy of Canaletto's brilliant, incisive, sharp brush that makes the whites and colors vibrate with an intense luminosity. The view of *Warwick Castle* is a masterpiece of light: it makes the spectator physically feel the dense, warm light of sunset that animates the gaudy colors of the ladies and gentlemen approaching the entrance; on the right the village cottages with their red roofs and gray-brown stone closely recall the authentic English countryside.

Several unique interior views painted during Canaletto's stay in England are worthy of note, for example, the view of the interior of the famous *Ranelagh Rotunda*, which is now in the National Gallery in London (Plate 34). This structure was a pavilion for special celebrations, where an orchestra played and people gathered to have drinks under the arcades, to talk, and to amuse themselves. This was a new opportunity for Canaletto to represent such a vital, lively scene, and brings to mind the magnificent *Feast of St. Rocco* of many years before. If it is true that Canaletto's approach had become more articulated and nervous, in an almost stenographic synthesis, it is just as true that none of his expressive power or chromatic capabilities had been lost.

In the meantime commissions from the great English families had begun to diminish, and Canaletto, with his usual tempestuousness, decided to return to Venice; through the intercession of his faithful friend Smith, he had never interrupted his artistic relations with that city. Canaletto's last English work is the *Walton Bridge* (1754); shortly after completing this painting he returned to Venice.

Canaletto's later style, as seen in his Venetian works from after 1755, is undoubtedly different from that of his earlier works. The play of light between the different elements of a composition has become more harmonious and drawn out. His lines tend to become truncated, whether straight or curved to form human figures; people appear as clusters of incandescent light, like glass figures blown by a Venetian artisan.

This same quality is found in Canaletto's late drawings, for example, the sheet with the *Florian Café* now at Windsor. These are drawings of an even, flowing quality, without sudden movements, in

North Transept of St. Mark's
*Windsor, Royal Library*

which the capable, experienced hand of the master puts everything in its proper place. Of this type is the drawing of *Players in St. Mark's Square* in the Victoria and Albert Museum, which is a mirror of crystalline light, brilliantly festive and animated.

This precise touch also characterizes Canaletto's late, small canvases in the National Gallery in London, *The Procuratie and the Florian Café* and *St. Mark's Square Seen from the Ascensione* (Plates 37–38). These works are touched by curved lines and luminous points that outline the capes and round or three-cornered caps and that render incandescent the gold and silver frames of the basilica in the background as well as the arched lamps under the porticos of the Procuratie. The work is carried out by means of measured strokes, with a careful, elegant motion, like the tempo of a minuet at the end of a musical *scherzo.*

This is also the quality of a series of drawings of the twelve *Doge's Feasts,* which were engraved by Brustolon some time before 1766. These are drawings of an almost exasperating precision, which suggests that perhaps Canaletto's imagination and inventiveness were beginning to wane. And yet, aside from the fact that this minute precision can at least partially be explained by the fact that these drawings were intended to be translated into engravings, they also correspond to the artist's sincere and genuine state of mind and his unflagging respect for the myth of Venice as manifested in its ceremonies such as the Doge's feasts which celebrated that myth against the backdrop of her great monuments.

Canaletto's last picture is an *Architectural Perspective* (Plate 39), the piece he presented to the Academy upon his admission as a member in 1765. This is another painting a *capriccio,* perhaps because Canaletto did not want to offer his colleagues one of his typical views destined for foreign collectors. It is a cleverly devised perspective, aimed at demonstrating Canaletto's technical virtuosity; but it is strange that such a great painter of reality should end his career with an abstract academic exercise.

For this reason we have chosen to conclude this critical discussion of Canaletto's works with the consideration of a more authentic creation, once again chosen from among his drawings. It is a unique sheet, with the artist's own annotations, of the *Choristers in St. Mark's* (Plate 40), now in Hamburg. Canaletto writes at the bottom of the sheet that he drew it at the age of 68 "without eyeglasses," and it is a miracle of meticulous attention to reality, diametrically opposed to the free, spontaneous style of Francesco Guardi.

We would like to end this study with a few remarks on the history of Canaletto criticism, which constitutes a vast bibliography.

From contemporary sources there emerges a picture of Canaletto as an exceptionally successful artist. Already in the letters of Marchesini and McSwiney (1725–27) he was judged superior to his fellow painters. That "sun" which shone within his pictures, that "truth" which bestowed a sense

of authenticity even on pictures painted from memory in the studio, tended to cause Canaletto to be considered — perhaps with a bit of exaggeration — as a unique phenomenon in Venetian painting: "the eye is deceived, and believes that it is seeing reality rather than a picture of reality," the Orlandi-Guarientis wrote in 1753. Even more significant is the acute assessment of Zanetti (1771), who recognized that Canaletto's depiction of reality was so extraordinary that, looking at his pictures, one received an impression of sublime perfection, "which surpasses that of Nature itself."

Thus already by the end of the eighteenth century critics had begun to realize that Canaletto's realism was in many ways different from, and even superior to, a mere optical reproduction of topographical reality. The highly rational Lanzi (1795), for example, emphasized the positive aspects of what he called the "liberties" that Canaletto took with reality.

Naturally it was inevitable that in the nineteenth century, with the advent of the Romantic esthetic, the "enlightened" attitude inherent in Canaletto's paintings should be seen in a negative light. In fact few of his pictures made their way into the great nineteenth century museums. Ruskin (1843-60) even went so far as to write that Canaletto's draftsmanship was "imprecise, technically weak, and with little inspiration." The high artistic quality of Canaletto's work has come to be fully appreciated in the twentieth century, and it is interesting to note that this appreciation originated with an assessment of his exceptional graphic abilities. Focillon (1918) was the first to point out the importance of Canaletto's engravings, followed by specialists such as Calabi (1931), Pittaluga (1934), and De Witt (1941). Critical study of his drawings also began in the first decades of this century, reaching a point of particular interest with Von Hadeln's anthology (1930), which proposed the notion of Canaletto as a realistic painter by means of a study of his original ideas as seen in his drawings. The documentary studies that continued until his biography was complete also began about this time, with the works of Finberg (1921–22) and Constable (1921).

In our generation there has been no doubt as to Canaletto's artistic abilities, and he is universally considered one of the greatest artists of eighteenth century European painting. Scholars have advanced their studies on the various technical aspects of Canaletto's work, for example, his method of etching (Pallucchini & Guarnati, 1945; Bromberg, 1974); his use of the optical chamber (Moschini, 1954; Pignatti, 1958; Ragghianti, 1958; Gioseffi, 1959); his early works (Morassi, 1966; Pallucchini, 1973); the objective credibility of his depictions (Corboz, 1974); his early experience in the field of scenography (Povoledo, 1954); and the cataloging of his drawings (Pignatti, 1969).

Numerous monographs on Canaletto have also appeared, from Watson's (1954) to those of Moschini (1954), Brandi (1960), Puppi (1968), and Pignatti (1976). The work by Constable (1962, revised by Links in 1977) stands out among all these monographs for its detail and comprehensiveness. Constable catalogs and annotates

Canaletto's entire opus — paintings, drawings, and engravings — and provides an exhaustive documentary and critical bibliography.

A final indication of Canaletto's immense popularity in our times — in addition to the huge commercial value of his works — is provided by two recent extensive exhibitions: one coordinated by Constable in Canada (1964–65) and one in Venice in 1967 — the section of works by Canaletto that Zampetti included in the exhibition of *vedutisti*.

# Color Plates

## 1 - ROMAN RUINS

*Canvas, 113 × 149 cm.*
*Venice, Private Collection (Eliofoto)*

This canvas, along with its companion piece *(Porto Romano),* is part of a group of paintings that recent study has assigned to the beginning of the third decade of the eighteenth century. The scenographic format and the Ricciesque handling of light relate this work to the series of Tombs painted for McSwiney from 1722 on. (Constable-Links, 1977, n. 500)

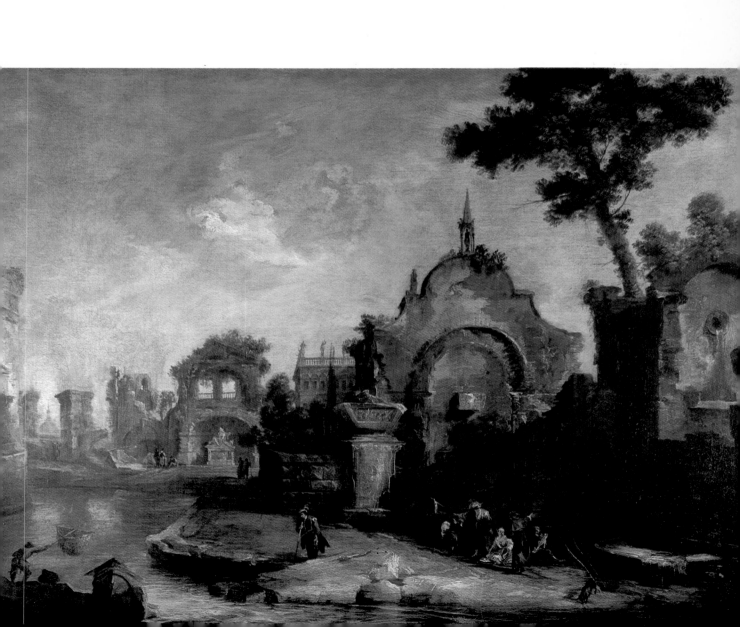

## 2 - FANTASTIC TOMB OF LORD SOMERS

*Canvas, 279.4 × 142 cm.*
*Oakly Park (Shropshire), Collection of the Count of*
*Plymouth (Trapman Photo)*

An unsuccessful theatrical impresario, Owen
McSwiney, commissioned a series of canvases from
Canaletto around 1722, which were to represent
imaginary funerary monuments dedicated to famous
Englishmen; the canvases were sold to the Duke of
Richmond. While the architectural elements of this
painting are by Canaletto, the human figures were
added by Piazzetta and the landscape by Cimaroli
(Constable-Links, 1977, n. 516)

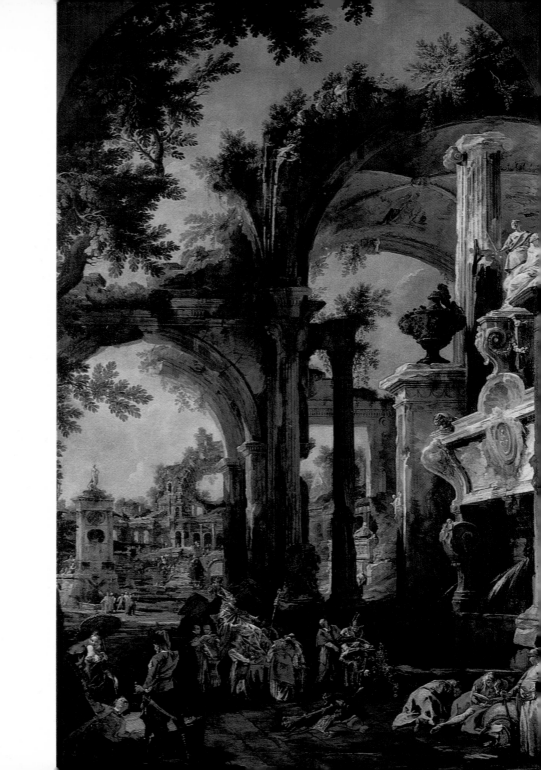

## 3 - THE RIALTO BRIDGE

*Drawing, 141 × 202 mm., pen and brown ink*
*Oxford, Ashmolean Museum*

This is a preparatory drawing for a painting
commissioned in 1725 by Stefano Conti of Lucca,
along with three other pictures. The annotation ''sole''
(sun) at the lower right corresponds to the illuminated
area of the painting, which is now in a private
collection in Montreal.
(Constable-Links, 1977, n. 593)

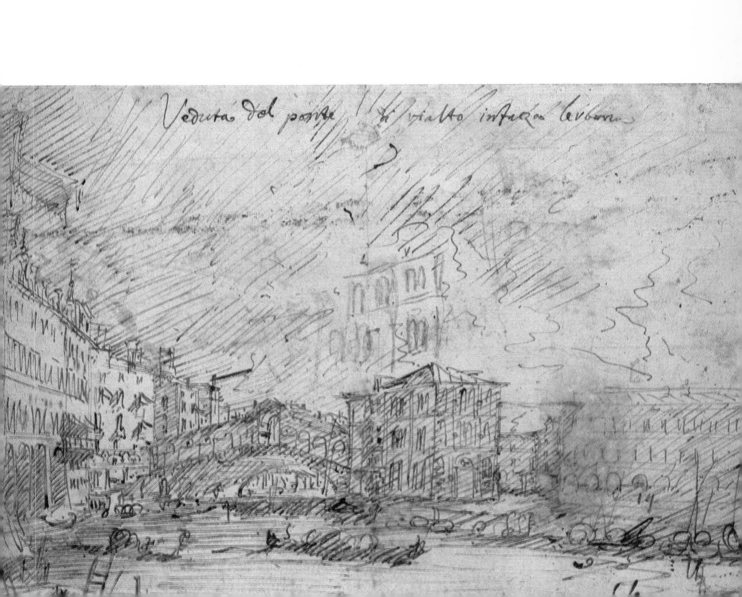

*Veduta del ponte il rialto infaccia levbon*

## 4 - THE RIALTO BRIDGE

*Canvas, 91.5 × 134.5 cm.*
*Montreal, Private Collection*

Between 1725 and 1726, through the mediation of the
painter Marchesini, the architect Stefano Conti of Lucca
ordered four canvases from Canaletto, of which this
was the first. In his correspondence regarding this
transaction, Marchesini emphasized the fact that
Canaletto always painted ''from life.''
(Constable-Links, 1977, n. 234)

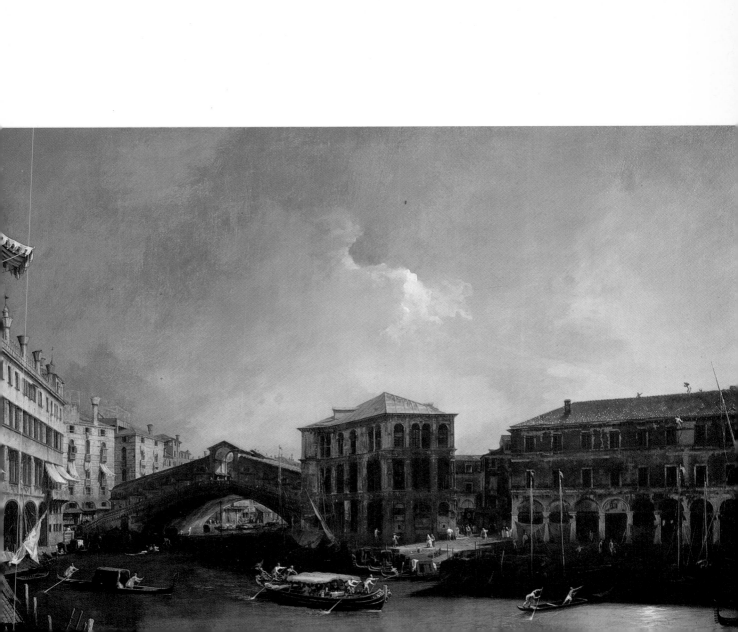

## 5 - THE GRAND CANAL TOWARD THE RIALTO BRIDGE

*Canvas, 144 × 207 cm.*
*Milan, Private Collection*
*(Photo Scala)*

This is part of a series of four canvases formerly in the collection of the Prince of Liechtenstein. (In this series the painting of St. Mark's Square can be dated before 1723; The dating is possible because Canaletto represented the square without the pavement that was added in 1723). The play of shadows is carried out by scenographic artifices along the row of houses that terminates in the Rialto Bridge.
(Constable-Links, 1977, n. 210)

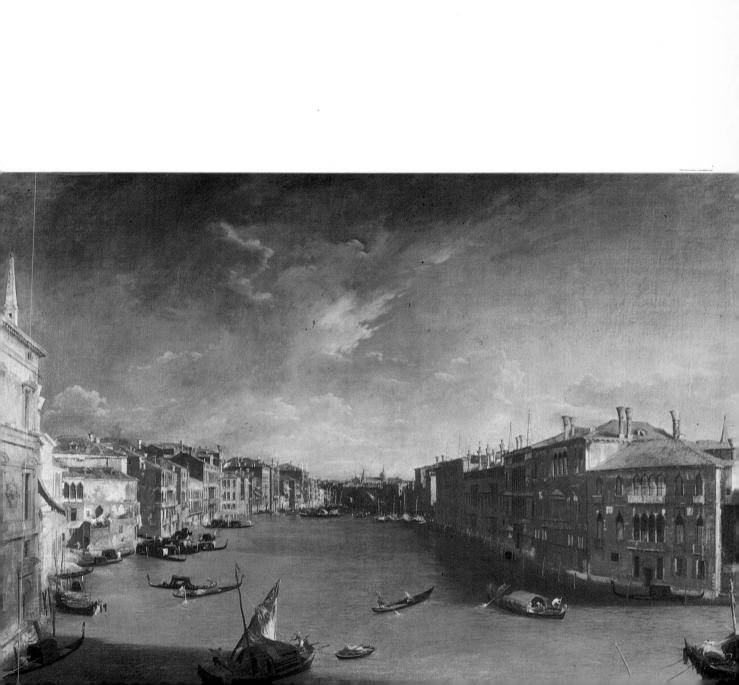

**6 - THE CLOCKTOWER AS SEEN FROM THE PIAZZETTA**

*Canvas, 170.2 × 129.5 cm.*
*Windsor Castle, Royal Collection*

Around 1726–28 Canaletto carried out six views of St.
Mark's for Joseph Smith, his great patron, and this is
one of them. A preparatory drawing is also at Windsor.
From the Smith Collection this work passed in 1763 to
the collection of George III of England.
(Constable-Links, 1977, n. 63)

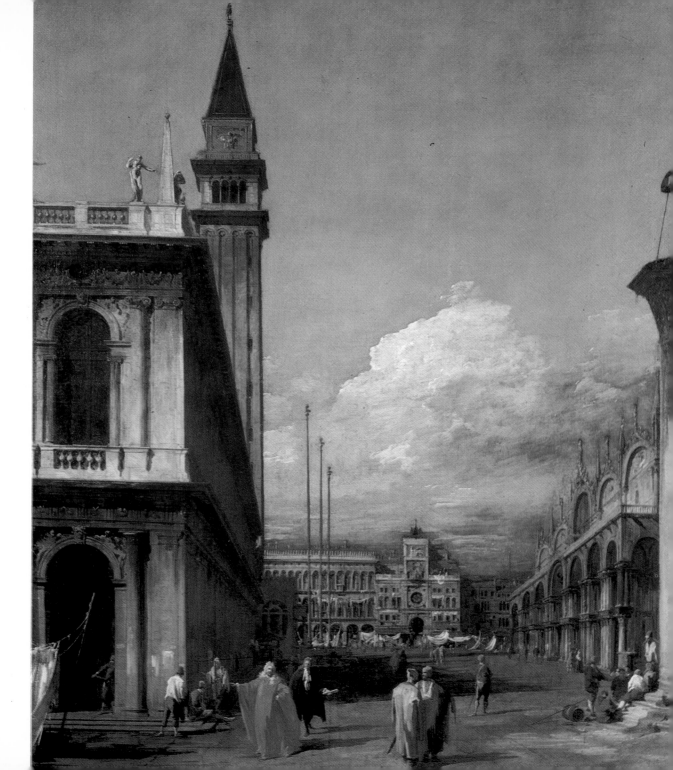

7 - ST. MARK'S BAY AS SEEN FROM THE GIUDECCA

*Canvas, 141 × 152.5 cm.*
*Cardiff, National Museum of Wales*

This work, which was in the Philips Collection during the nineteenth century, is one of the first great panoramic views painted by Canaletto, probably between 1725 and 1730. The vantage point is the Giudecca promontory near San Giorgio.
(Constable-Links, 1977, n. 143)

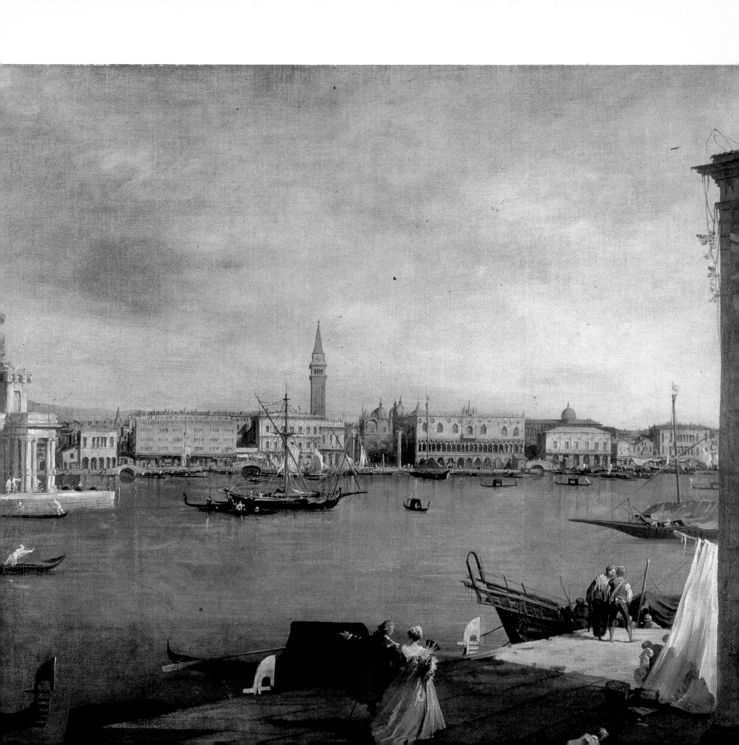

## 8 - THE STONECUTTER'S YARD

*Canvas, 124 × 163 cm.*
*London, National Gallery*

Formerly in the collection of Sir George Beaumont (1808), this canvas represents the marble workshop that occupied the area between San Vidal and the Cavalli palace during the eighteenth century; today it is the sight of the Academy Bridge. On the opposite side of the Grand Canal we see the Confraternity and church of the Carità, whose belltower has been destroyed. The style of the masterpiece indicates a date around 1730 on account of the intense shadows and dynamic use of colors.
(Constable-Links, 1977, n. 199)

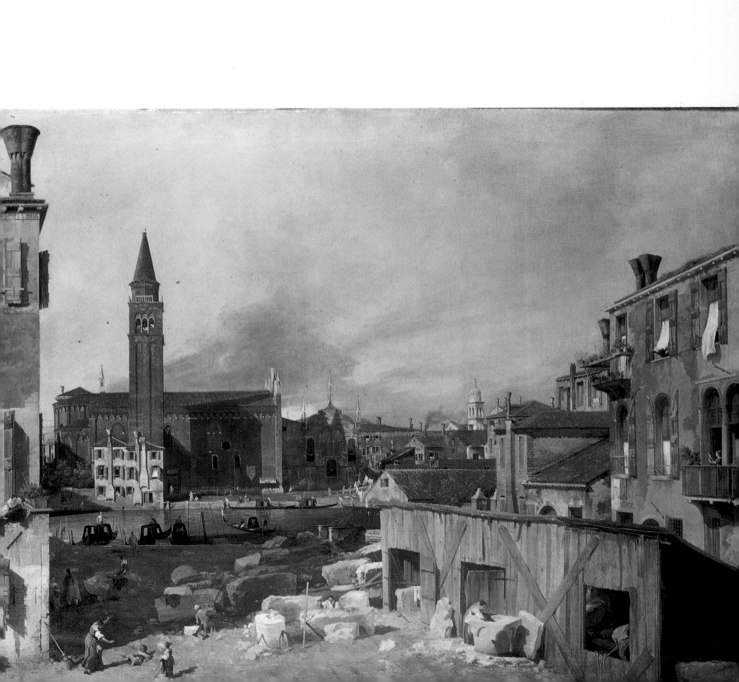

## 9 - THE FLOUR WAREHOUSE

*Canvas, 66 × 112 cm.*
*Venice, Giustiniani Collection*
*(Photo Giacomelli)*

Formerly the Office of Victualling, this building became
the Academy of Painting and Sculpture in 1756,
presided over by Tiepolo; today it is the location of the
Port Authority. This is an early work, around 1730,
judging from the proportions of the human figures and
the color accents.
(Constable-Links, 1977, n. 99)

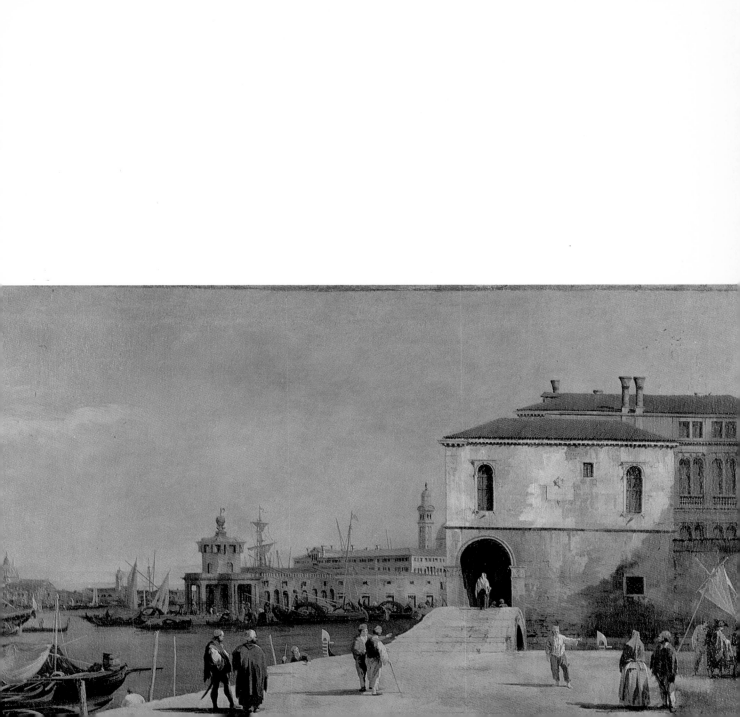

## 10 - CAMPO SANTA MARIA FORMOSA

*Black and red pencil drawing with brown ink, 230 ×
340 mm.
Venice, Academy
(Eliofoto)*

This is from a sketchbook used by Canaletto to
document and prepare for paintings. Modern scholars
have wondered whether Canaletto availed himself of an
''optical chamber'' (see text). The sketchbook dates
from around 1730.
(Constable-Links, 1977, n. 635)

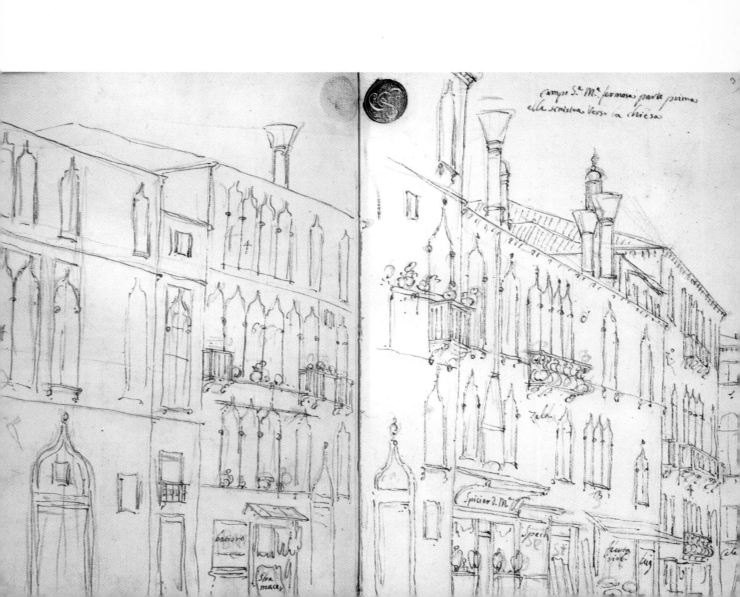

Campo S.ª M.ª formosa parte prima
alla sinistra verso la chiesa

## 11 - CAMPO SANTA MARIA FORMOSA

*Canvas, 47 × 80 cm.*
*Woburn Abbey, Collection of the Duke of Bedford*

This is one of the series of twenty-four canvases that
Canaletto painted around 1730, which were acquired
in Venice by the fourth Duke of Bedford. The
preparatory drawing for this picture is in a sketchbook
in the Academy in Venice; another "finished" drawing
is at Windsor and probably represents the final phase of
work on the painting.
(Constable-Links, 1977, n. 278)

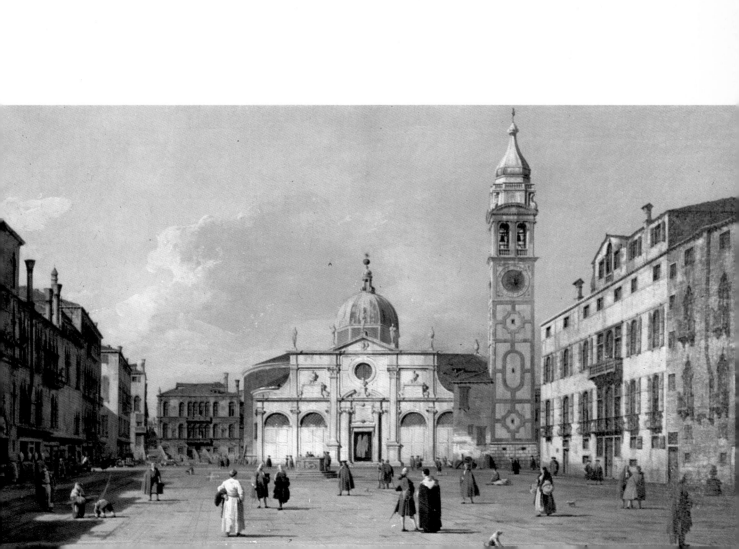

## 12 - THE RECEPTION OF THE IMPERIAL AMBASSADOR

*Canvas, 184 × 265 cm.*
*Milan, Private collection*
*(Photo Scala)*

This canvas depicts the presentation in Venice of the Count of Bolagno, imperial ambassador (to whom it belonged), on May 16, 1729. The traditional format repeats that of similar scenes painted by Carlevaris and by Canaletto himself: but here the colors have an unprecedented liveliness, which has its focal points in the three gilded gondolas, depicted in minute detail. (Constable-Links, 1977, n. 355)

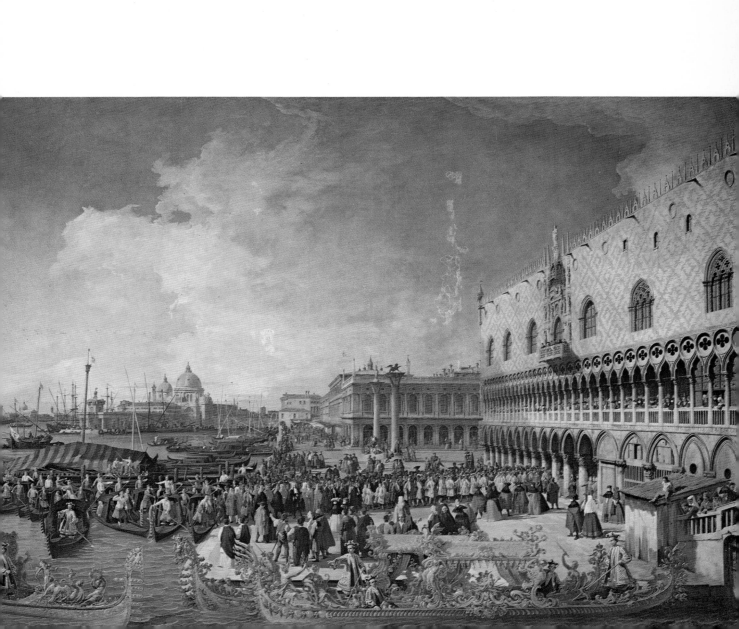

## 13 - THE REGATTA ON THE GRAND CANAL

*Canvas, 121 × 183 cm.*
*London, National Gallery*

Formerly in the possession of the Duke of Leeds, this canvas represents a Carnival regatta as can be deduced from the masked spectators. The coat of arms on the wooden construction that marks the finish line is that of Alvise Pisani, who was Doge from 1735–41; the canvas probably dates from these years. There are other versions of this same subject at Windsor, at Woburn Abbey, and also in the National Gallery. (Constable-Links, 1977, n. 350)

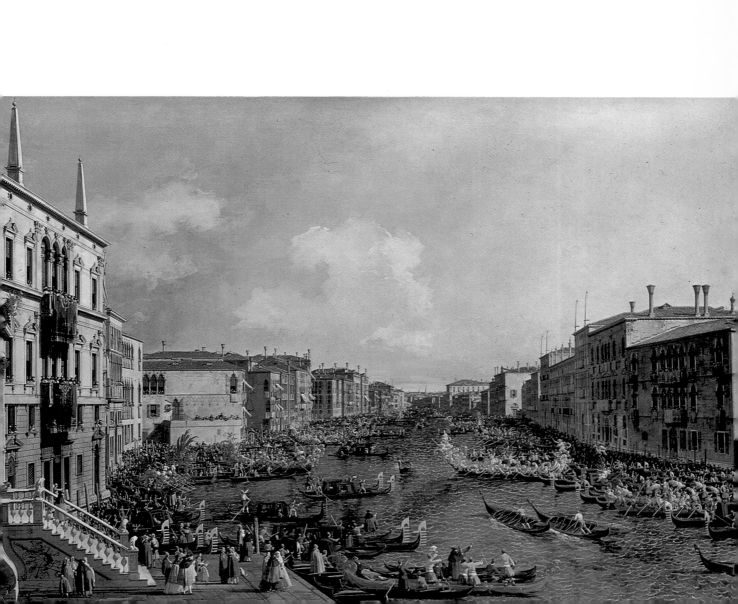

## 14 - THE FEAST OF ST. ROCCO

*Canvas, 147 × 199 cm.*
*London, National Gallery*

During the nineteenth century this painting was in the collection of the Vatican. On August 16 the Doge traditionally visited the votive church of St. Rocco, outside of which were exhibited paintings by artists who were members of the Fraglia: we can readily identify here works by Tiepolo, Piazzetta, Marco Ricci, and Canaletto himself, from which we can deduce a date around 1734.
(Constable-Links, 1977, n. 331)

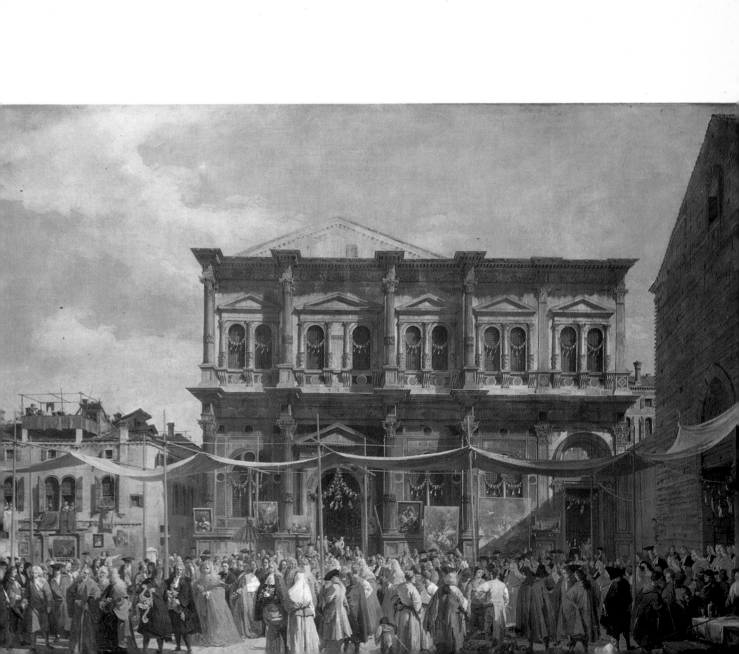

## 15 - THE WHARF AND THE OLD LIBRARY

*Canvas, 110.5 × 185.5 cm.*
*Rome, Private Collection*

Formerly in the collection of the Duke of Leeds, this is one of Canaletto's masterpieces, dating from around 1740, a date suggested by the particular color effects of the figures in the foreground, as well as by the atmospheric shading under the portico of the Library. In Canaletto's time, a fishmarket was held on the adjacent wharf.
(Constable-Links, 1977, n. 95)

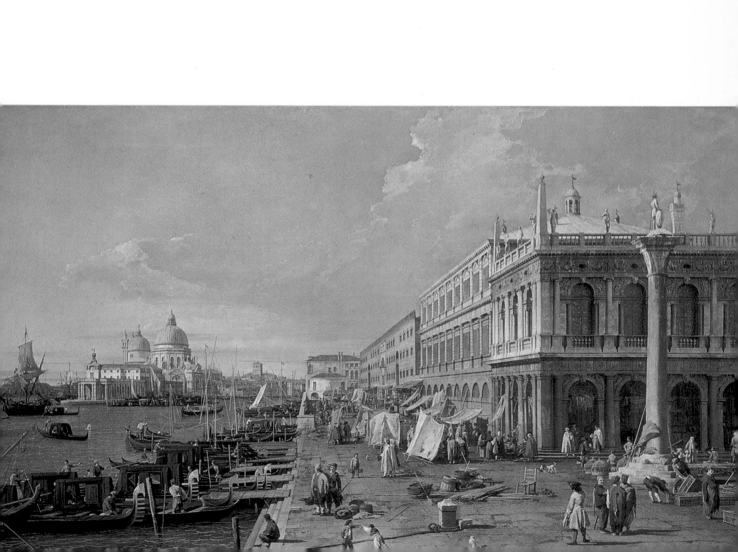

## 16 - THE ENTRANCE TO THE GRAND CANAL

*Canvas, 114.5 × 152.3 cm.*
*Washington, National Gallery (gift of Mrs. Barbara Hutton)*

This canvas, along with its companion piece *(St. Mark's Square Toward the Southeast),* was probably acquired in Venice some time after 1734 by the third Count of Carlisle; it later passed to the Castle Howard collection. Canaletto signed this work with the initials A.C.F. (Antonio Canal Fecit), almost as if he wanted to emphasize its importance: it is, in fact, an extraordinarily limpid and accurate representation. (Constable-Links, 1977, n. 154)

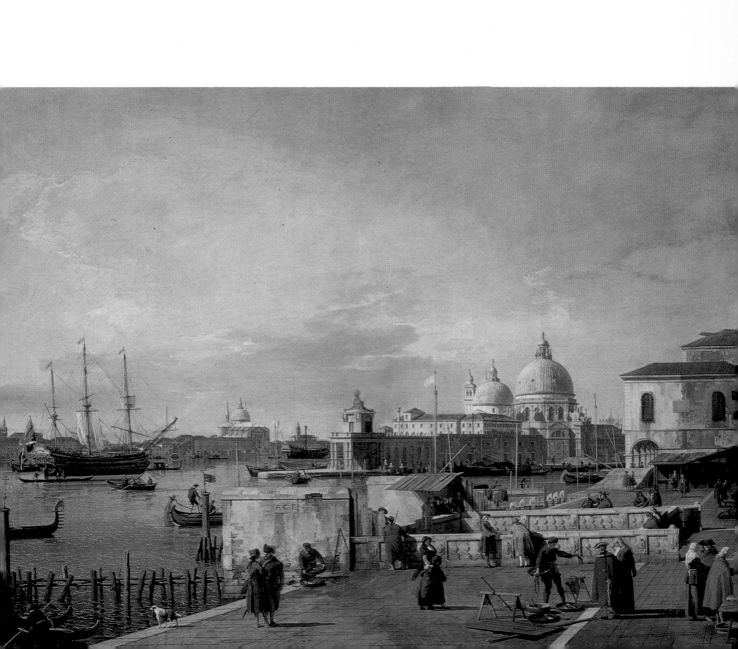

## 17 - ST. MARK'S SQUARE TOWARD THE SOUTHEAST

*Canvas, 114.2 × 114.5 cm.*
*Washington, National Gallery (gift of Mrs. Barbara Hutton)*

This is the *pendant* of the preceding painting and in all probability was acquired at the same time. This painting, too, is signed A.C.F., and is noteworthy for its warm golden-blond color intonation, which is typical of Canaletto's works from the early 1740s.
(Constable-Links, 1977, n. 50)

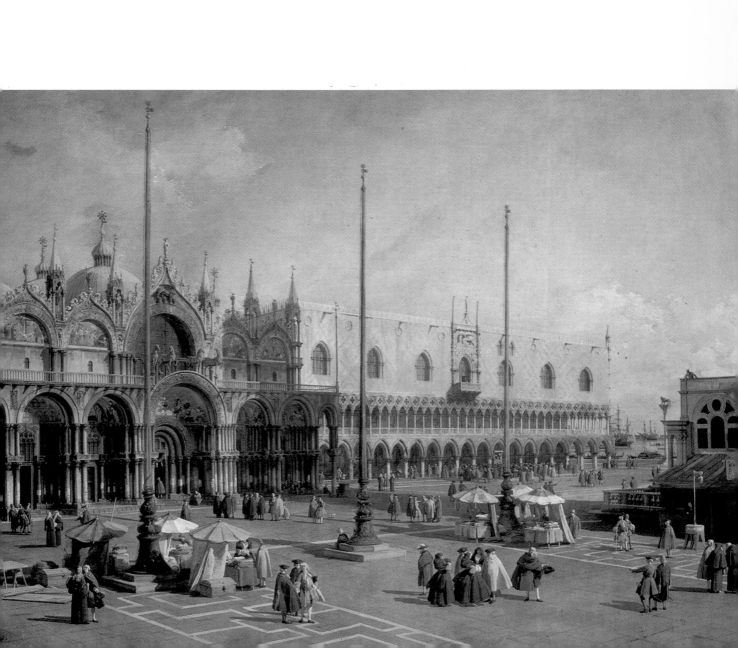

## 18 - ST. MARK'S BAY AS SEEN FROM THE PIAZZETTA
(detail)

*Canvas, 132 × 165 cm.*
*New York, Eugene Victor Thaw and Company*
*Collection*

This is one of a series of four canvases, painted for
William Holbech of Farnborough Hall, who had visited
Italy between about 1730 and 1745. These works,
which were hung in the dining hall, remained at
Farnborough Hall until 1930. This work is datable,
judging from its resemblance to the paintings for the
Count of Carlisle (Plates 17, 19), around 1740, the time
of the most luminous and limpid color in Canaletto's
production.
(Constable-Links, 1977, n. 128)

## 19 - ST. MARK'S BAY

*Canvas, 125 × 204 cm.*
*Boston, Museum of Fine Arts*
*(Lawrence, Sweeser, and French Funds)*

This work almost certainly comes from a group of paintings acquired in Venice by the third Count of Carlisle some time after 1734. In 1745 in fact, several ''recently hung'' paintings by Canaletto were described by Lady Oxford as having been seen in a room in Howard Castle, at that time the residence of the fourth Count of Carlisle.
(Constable-Links, 1977, n. 131)

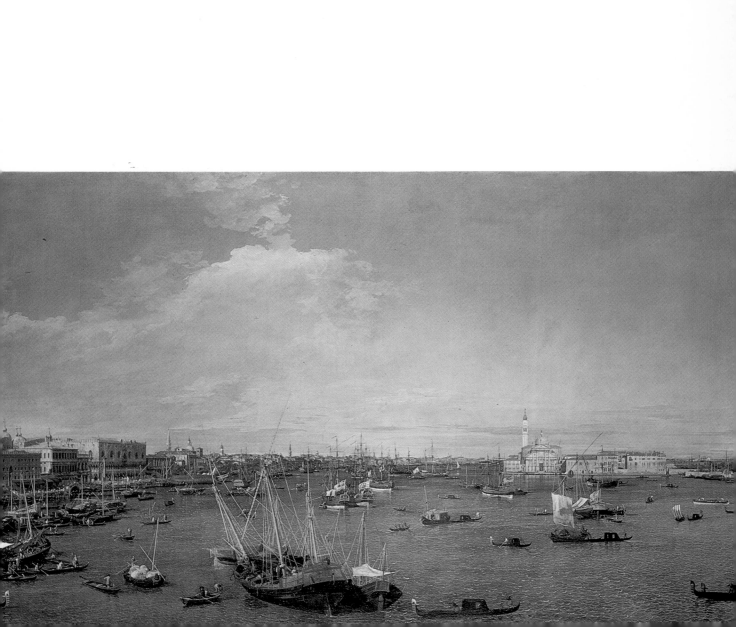

## 20 - ST. MARK'S BAY AS SEEN FROM SAN GIORGIO

*Canvas, 127 × 188 cm.*
*London, Wallace Collection*

This canvas came from the collection of the Marquis of
Hertford and should be considered along with the
typical "wide-angle" views carried out by Canaletto
during the fifth decade of the eighteenth century. The
vantage point here is the island of San Giorgio, but the
perspective is distorted by the use of the wide-angle
lenses of the optical chamber.
(Constable-Links, 1977, n. 137)

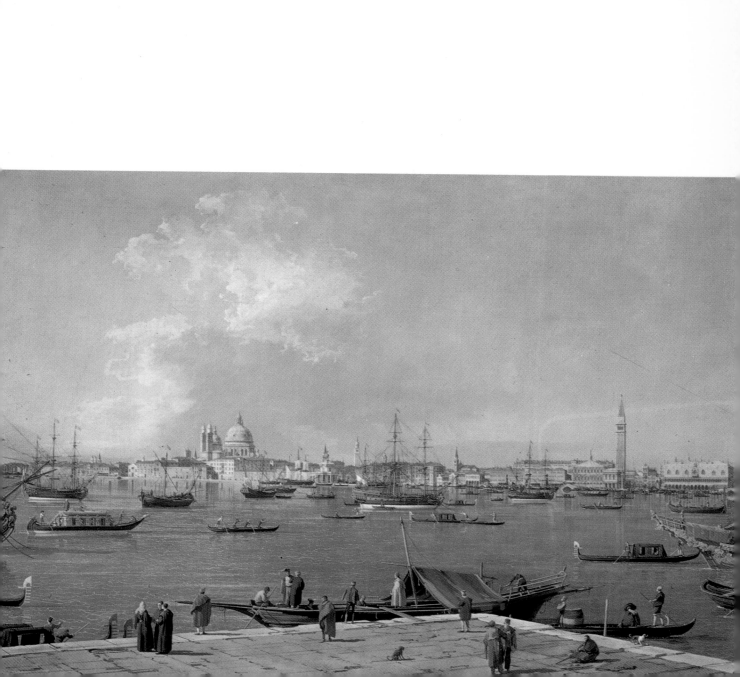

## 21 - THE CUSTOMS HOUSE PROMONTORY

*Canvas, 46 × 62.5 cm.*
*Vienna, Kunsthistorisches Museum*
*(Meyer Photo)*

This work came from the collection of the Prince of
Liechtenstein, who acquired a dozen canvases by
Canaletto in Venice in 1740. The picture is
characteristic of this phase in Canaletto's career, when
he was using extraordinarily brilliant colors, applied
with minute brushstrokes, which highlight the points of
illumination with clusters of color.
(Constable-Links, 1977, n. 156)

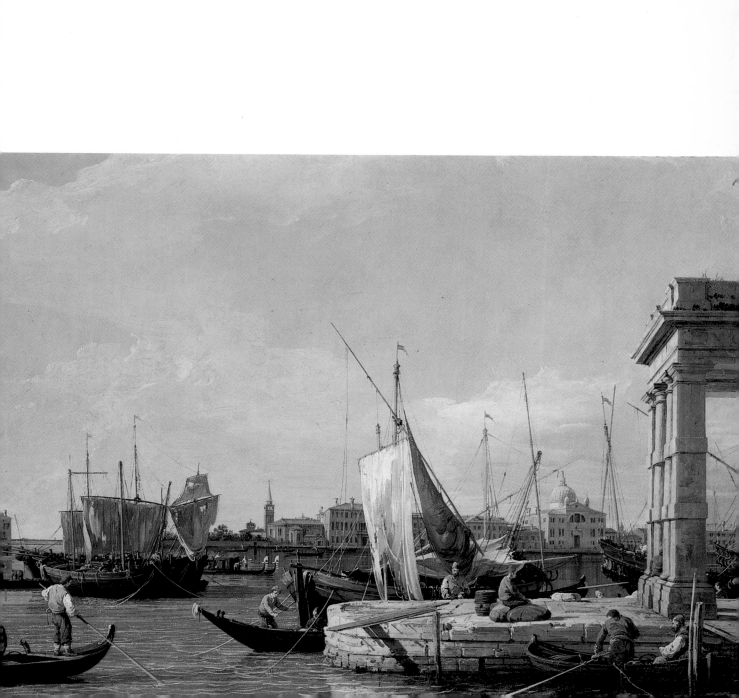

## 22 - THE BAY AS SEEN FROM SANT'ANTONIO

*Black chalk. brown ink, and gray wash drawing, 157 ×
346 mm*
*Windsor Castle, Royal Library*

This drawing was in Joseph Smith's collection, which
was sold to George III of England in 1763. The vantage
point is the current location of the Castello Gardens.
This masterpiece, datable around 1740, can be related,
on account of its wide-angle perspective, to the
magnificent canvases in Boston and London.
(Constable-Links, 1977, n. 522)

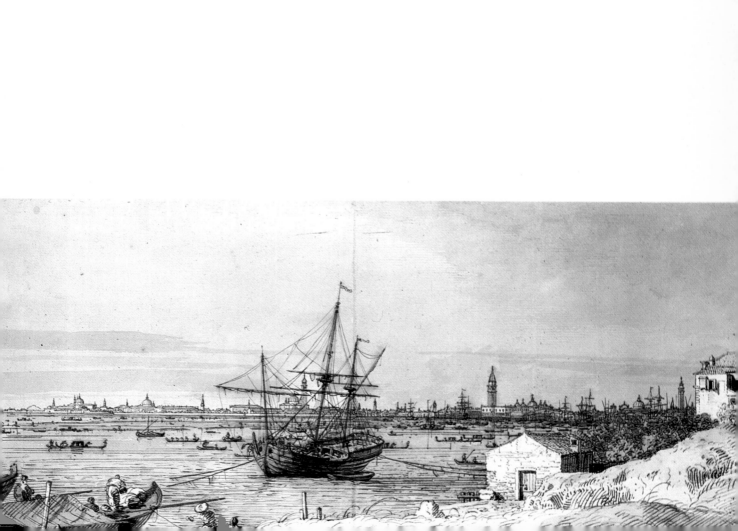

## 23 - THE ISLAND OF SANT'ELENA AND THE CHARTERHOUSE

*Black chalk, brown ink, and gray wash drawing, 155 × 350 mm.*
*Windsor Castle, Royal Library*

This drawing, too, was in the Smith collection that was later sold to George III. The angle is the same as in the preceding drawing, looking eastward. The panorama includes the Servite monastery of Sant'Elena and the island of the Charterhouse.
(Constable-Links, 1977, n. 650)

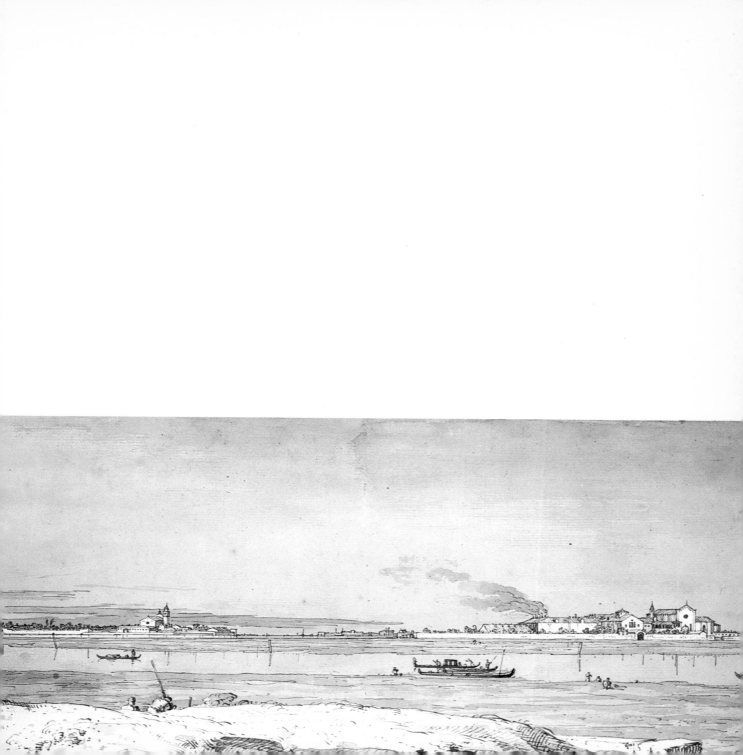

## 24 - THE MARGHERA TOWER

*Etching, 297 × 427 mm.*
*(Photo Toso)*

At the edge of the lagoon, today the location of Porto Marghera, was this watchtower, which Canaletto immortalized in one of his most famous prints—one of the series published in 1744 on the occasion of his patron Joseph Smith's election to the post of Consul. (Constable-Links, 1977, p. 654)

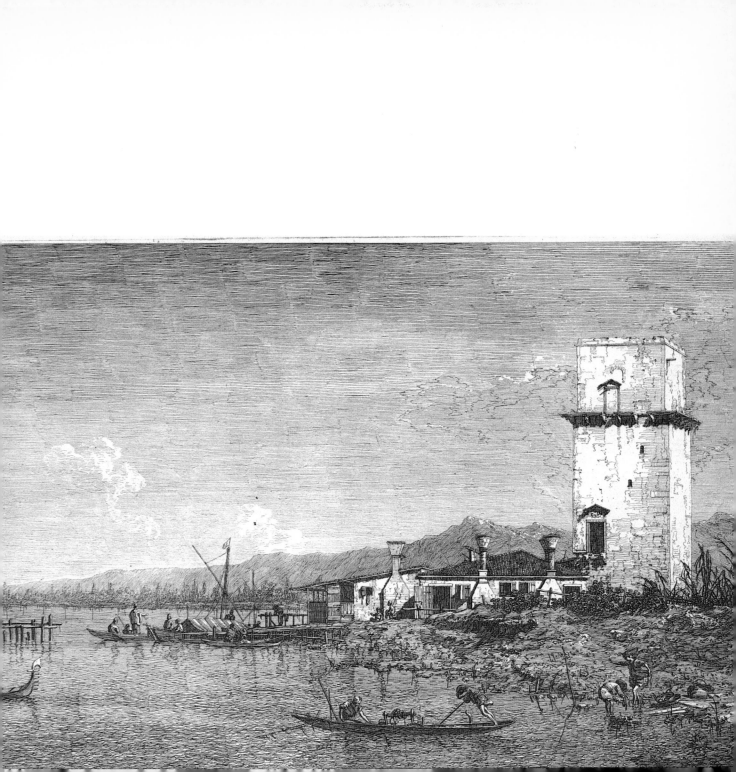

## 25 - THE ENTRANCE TO CANNAREGIO

*Canvas, 46.5 × 78 cm.*
*Venice, Cassa di Risparmio*

This painting was in the Spenser Hall Collection and later the Stopford; it is now at Windsor. Numerous versions of this subject exist, for Cannaregio was a well-known point of interest. Canaletto had first painted the entrance to Cannaregio for Joseph Smith some time before 1735. After 1742 a statue was placed on the embankment and appears only in this canvas, which is also distinguished by its scintillating color and minute draftsmanship.
(Constable-Links, 1977, n. 251, d. 4)

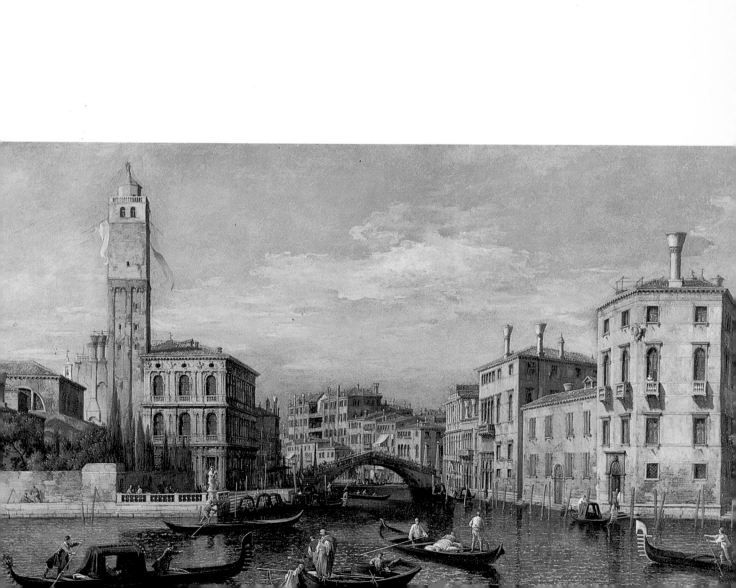

## 26 - ST. MARK'S SQUARE

*Canvas, 67 × 103 cm.*
*Hartford, Wadsworth Atheneum*

This is one of Canaletto's most typical "wide-angle" views from the fifth decade of the century. It presents, as we can obviously see, a visual angle that would be impossible for the naked eye and one that is realized by means of a combination of views with the "optical chamber."
(Constable-Links, 1977, n. 54)

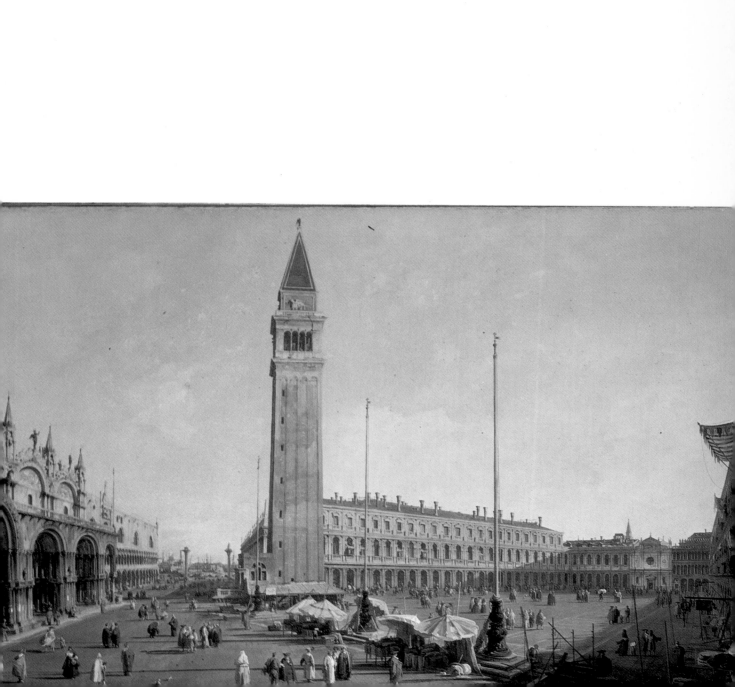

## 27 - THE PANTHEON

*Canvas, 179 × 106.5 cm.*
*Windsor Castle, Royal Collection*

This is one of several views of Rome dated 1742 that Canaletto painted for Joseph Smith and that passed to George III's collection at Windsor in 1763. It has not been definitely proven that Canaletto returned to Rome in 1742. However it seems unlikely that these paintings could be the fruit of the painter's youthful memories or of sketches by his nephew Bellotto.
(Constable-Links, 1977, n. 390)

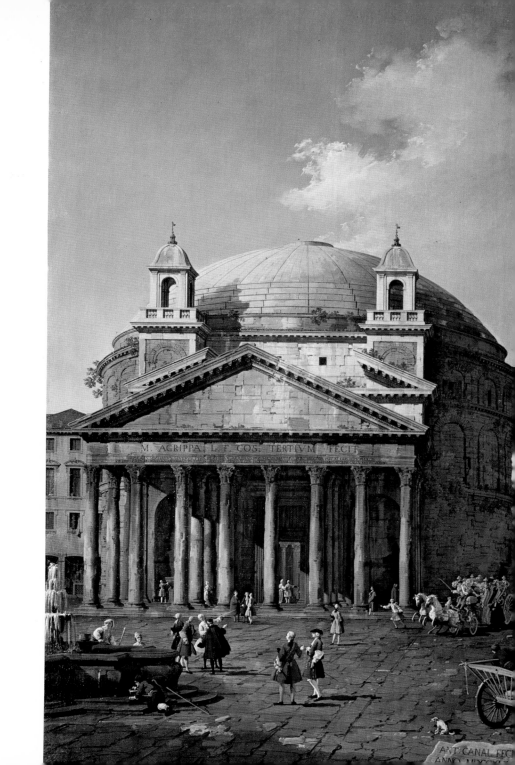

## 28 - THE PIAZZETTA AND THE DOGE'S PALACE
Bernardo Bellotto

*Canvas, 151 × 122 cm.*
*Ottawa, National Gallery of Canada*

Between 1738 and 1743 Bernardo Bellotto worked in his uncle Canaletto's workshop, mastering his style to such an extent that he even fooled contemporary connoisseurs. In this canvas, formerly in the collection of the Count of Morley (along with three others), Bellotto's style can be discerned in his more static brushstrokes, heavier shadows, and more "realistic" approach.
(Constable-Links, 1977, n. 67)

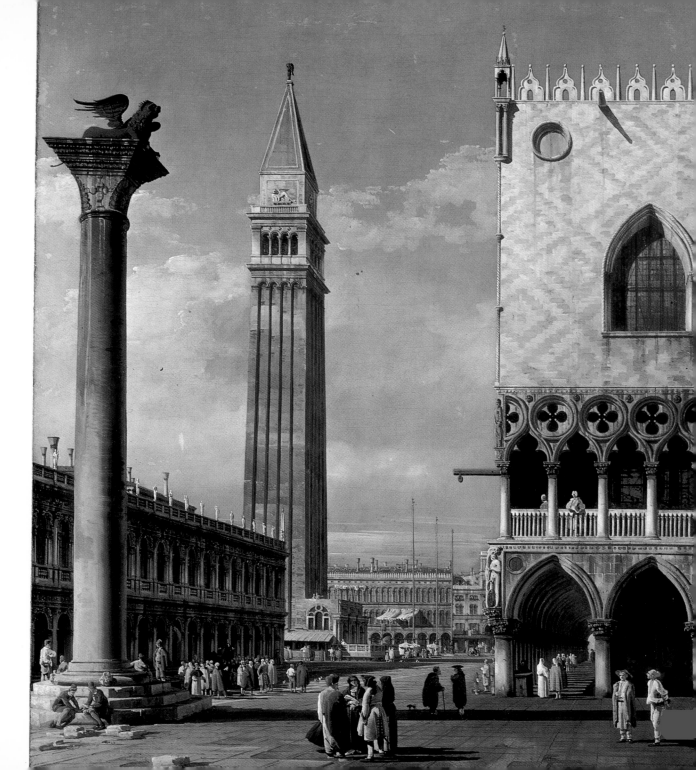

## 29 - *CAPRICCIO* WITH THE HORSES OF ST. MARK'S

*Canvas, 102 × 129.5 cm.*
*Windsor Castle, Royal Collection*

Canaletto painted thirteen views *a capriccio* for Joseph
Smith's house in Rialto, most of which are at Windsor
today. This type of fanciful composition was typical of
the mid-eighteenth century, and many of the
masterpieces of Canaletto's artistic maturity fall into this
category.
(Constable-Links, 1977, n. 451)

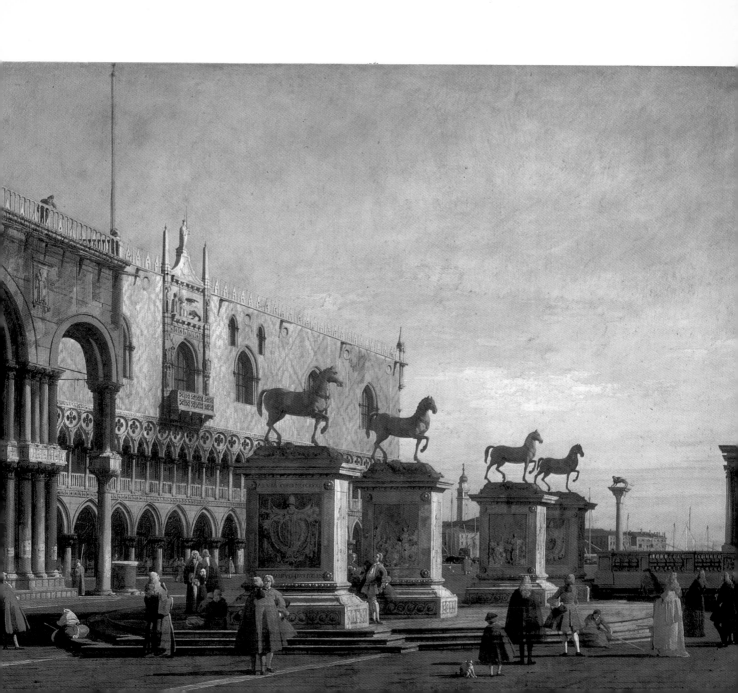

## 30 - THE THAMES TOWARD WESTMINSTER BRIDGE

*Canvas, 118 × 238 cm.*
*Prague, Narodni Galerie*
*(Fyman Photo)*

This work was in the collection of Prince Philip of Lobkovitz, who bought it from Canaletto in London. It is certainly one of the first works Canaletto painted in London, probably around 1746–47, a date supported by the fact that Westminster Bridge is depicted in a state of incompletion. The vantage point here is Lambeth Palace on the Thames.
(Constable-Links, 1977, n. 426)

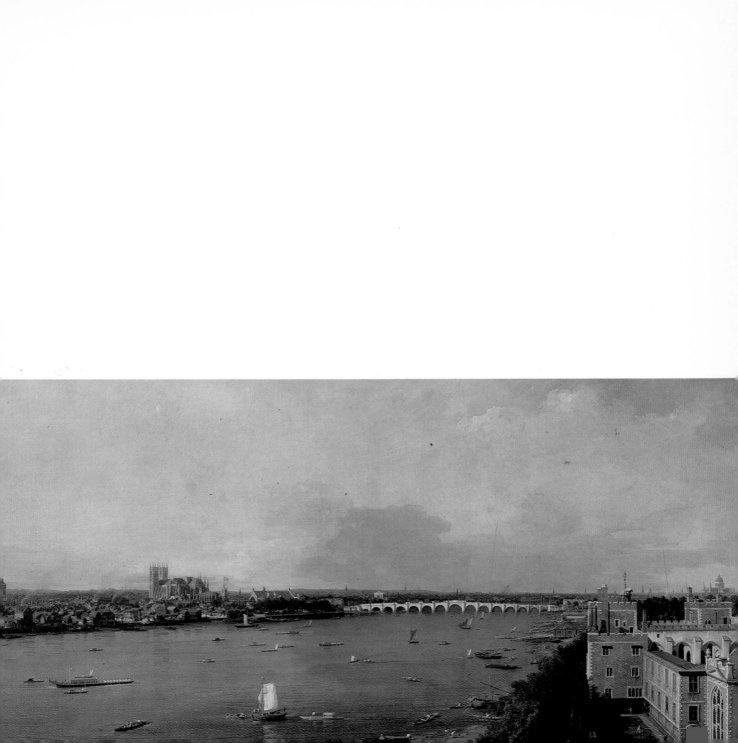

## 31 - BADMINTON PARK

*Canvas, 86 × 122 cm.*
*Badminton House, Collection of the Duke of Beaufort*
*(Harding Photo)*

In the summer of 1748 Canaletto was called to
Badminton House by the Duke of Beaufort. On that
occasion he painted this masterpiece, which the family
still possesses. Here Canaletto shows how he had
completely understood the particular nature of the
colors of the English countryside.
(Constable-Links, 1977, n. 410)

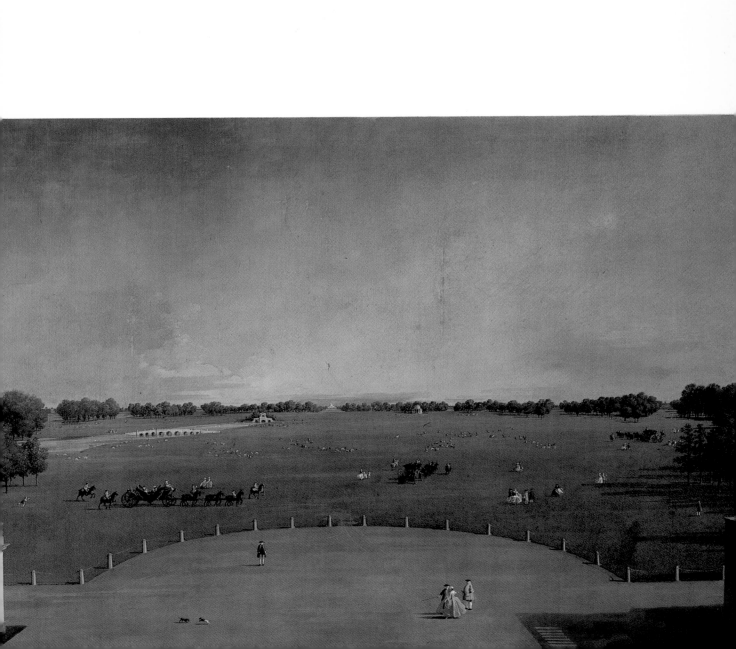

## 32 - THE THAMES SEEN FROM SOMERSET HOUSE

*Canvas, 105.5 × 186.5 cm.*
*Windsor Castle, Royal Collection*

This work was painted, along with its companion piece, for Consul Smith, probably in London, and was later brought to Venice on one of Canaletto's numerous trips home during his stay in England. The style in fact suggests a date around 1750. Evidently Canaletto wanted to present this wide view in minute detail, with extraordinary precision.
(Constable-Links, 1977, n. 428)

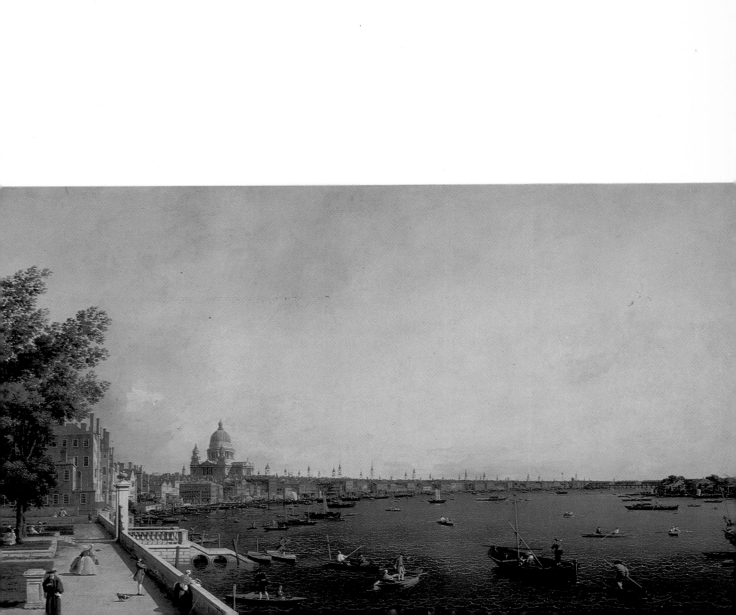

## 33 - WALTON BRIDGE

*Canvas, 46.5 × 75 cm.*
*London, Dulwich Gallery*
*(Photowork, Ltd.)*

This picture was executed for Thomas Hollins in 1754 and depicts the unique wooden bridge which M. P. Samuel Dicker built at Walton a short time before. In fact Dicker's house can be seen on the left; there is also a self-portrait of Canaletto intently drawing. (Constable-Links, 1977, n. 441)

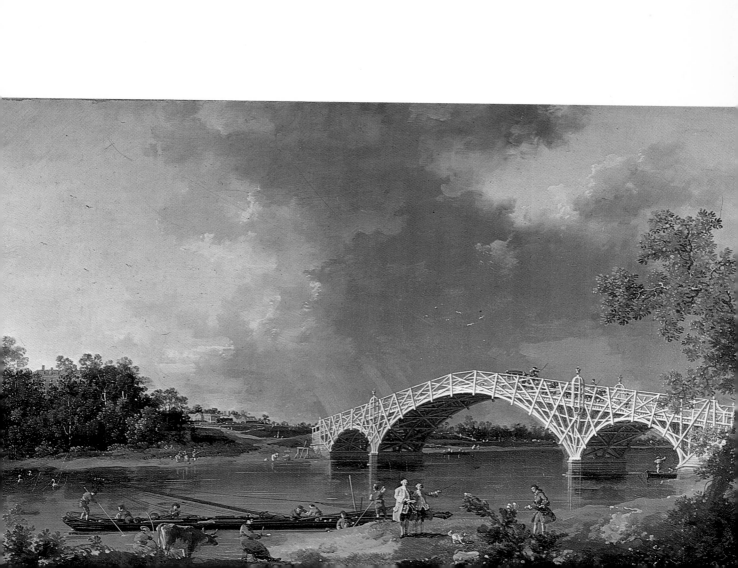

## 34 - THE RANELAGH ROTUNDA

*Canvas, 46 × 76.5 cm.*
*London, National Gallery*

Painted in London for Thomas Hollins in 1754, this work depicts a unique structure built in 1741 by William Jones in the park of Ranelagh House in Chelsea. The domed octagonal pavilion had a bar in the center and loges for the public on the sides. It also contained an organ that Mozart played in 1764. (Constable-Links, 1977, n. 420)

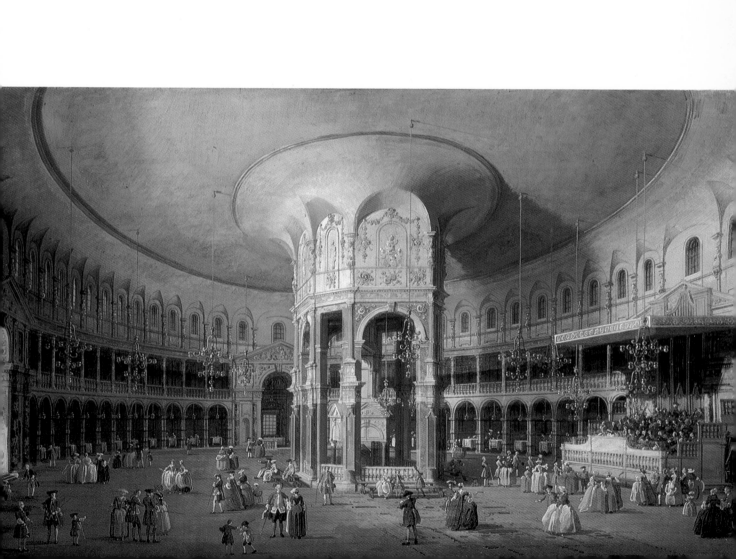

## 35 - VIEW OF THE PIAZZETTA TOWARD THE NORTH
(detail)

*Canvas, 75 × 118 cm.*
*Pasadena, Norton Simon Museum*

This work dates from around 1755–60, judging from its affinity with the "wide-angle" views in Hartford and in the Fogg Museum. The Clocktower appears without its upper floors, which were completed in 1760. Several drawings from a much earlier period (at Darmstadt and Windsor) can be linked to the same creative motif. The coloring is typical of this period in Canaletto's career: limpid and dry, with a crystalline quality.
(Constable-Links, 1977, n. 66)

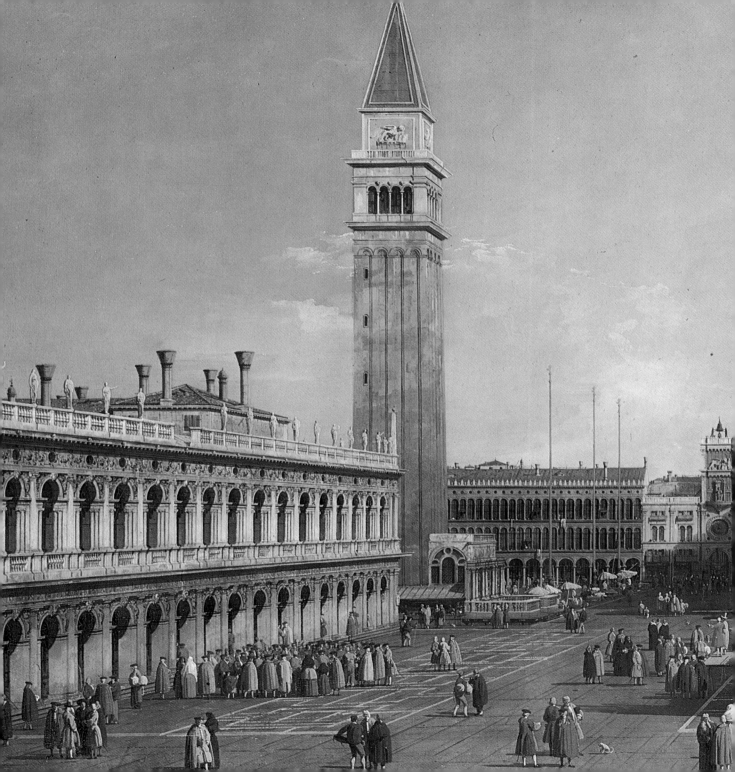

## 36 - *CAPRICCIO* WITH CLASSICAL RUINS

*Canvas, 87.5 × 120.5 cm.*
*Milan, Poldi Pezzoli Museum*

In his later years after his return to Venice Canaletto did many *capriccio* views, especially with classical ruins. Several versions of this painting, which was formerly in the collection of Langton Douglas, have survived: their varying quality suggests that at times Canaletto's artistic activity sunk to a commercial level. (Constable-Links, 1977, n. 497)

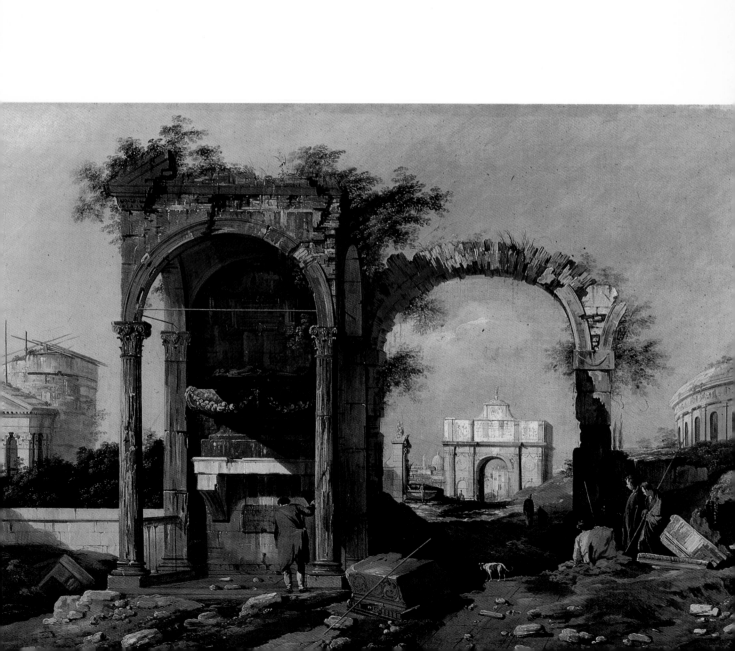

## 37 - THE PROCURATIE AND THE FLORIAN CAFÉ

*Canvas, 46.4 × 38.1 cm.*
*London, National Gallery*

This work, for which there exist numerous preparatory drawings, dates from some time before 1760, when the Clocktower was amplified. This highly refined canvas, formerly in the Salting Collection, which Canaletto probably painted shortly after his return to Venice from England, depicts the famous Florian Café under the Procuratie of St. Mark's.
(Constable-Links, 1977, n. 20)

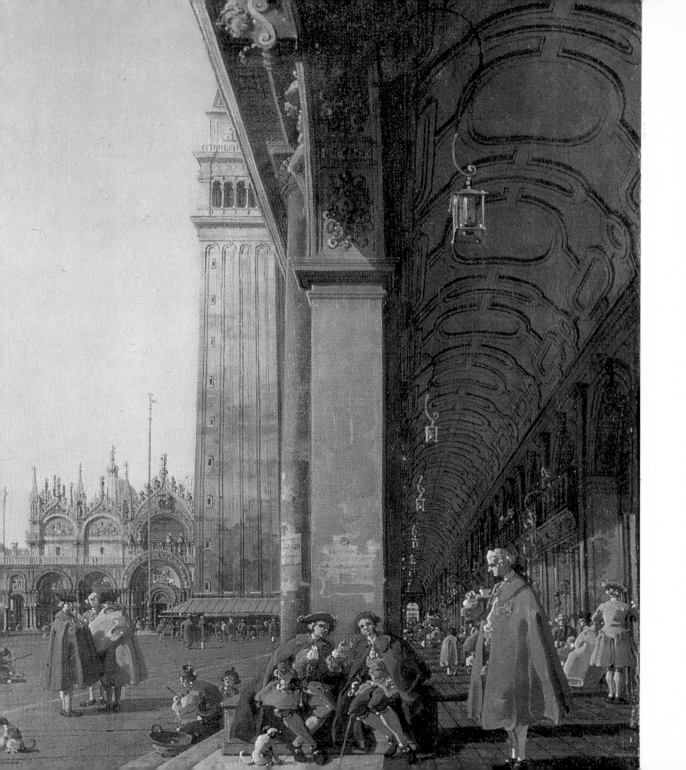

## 38 - ST. MARK'S SQUARE SEEN FROM THE ASCENSIONE

*Canvas, 46.4 × 37.8 cm.*
*London, National Gallery*

This, along with the preceding work, formed a pair of paintings that Canaletto did shortly after he returned from England. They passed into the George Salting Collection in 1886 and later to the National Gallery. Canaletto always seemed to prefer painting the other side of the square, with the Procuratie and Belltower foreshortened.
(Constable-Links, 1977, n. 21)

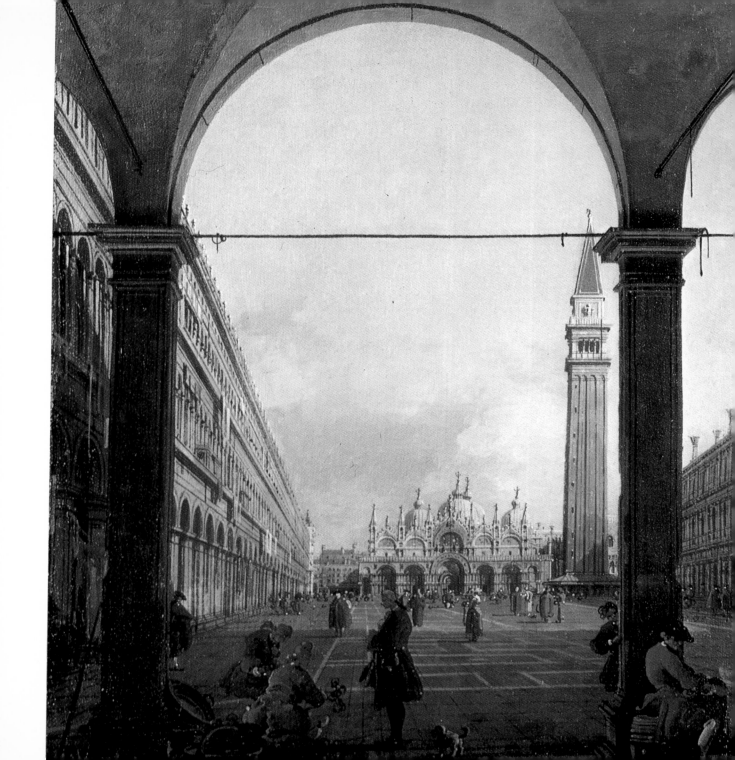

## 39 - ARCHITECTURAL PERSPECTIVE

*Canvas, 131 × 93 cm.*
*Venice, Academy*
*(Eliofoto)*

Signed and dated 1765, this is the canvas that Canaletto donated upon his admittance to the Academy. The treatment is *a capriccio,* with the intention of demonstrating Canaletto's perspective abilities. The colors, too, are quite beautiful, limpid, and full of luminous vibrations. There is a preparatory drawing for this work in the Correr Museum. (Constable-Links, 1977, n. 509)

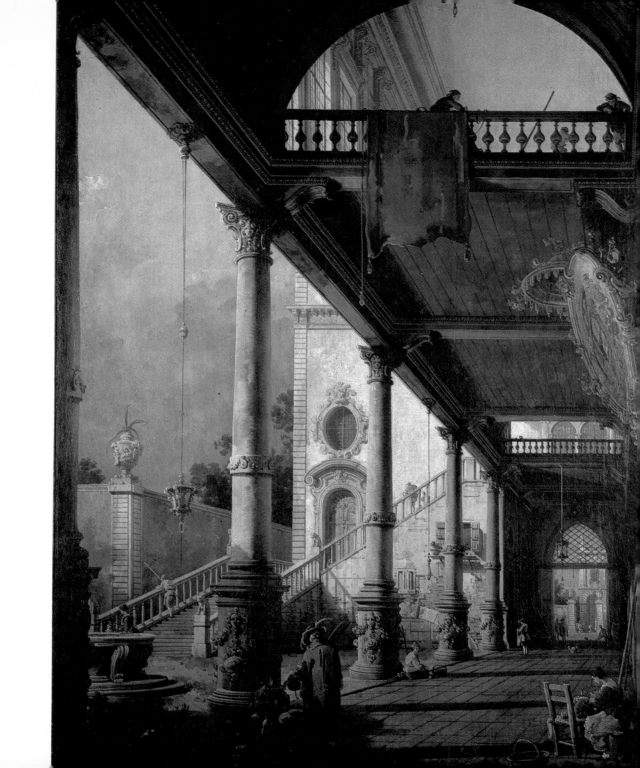

**40 - CHORISTERS IN ST. MARK'S**

*Black chalk, brown ink, and India ink wash drawing,*
*470 × 360 cm.*
*Hamburg, Manburger Kunsthalle*
*(Kleinhempel Photo)*

This drawing bears an autograph inscription with the
date 1766, two years before the artist's death. And yet,
the aged Canaletto writes, it was drawn "without
eyeglasses." This sheet can be considered one of
Canaletto's last works.
(Constable-Links, 1977, n. 558)

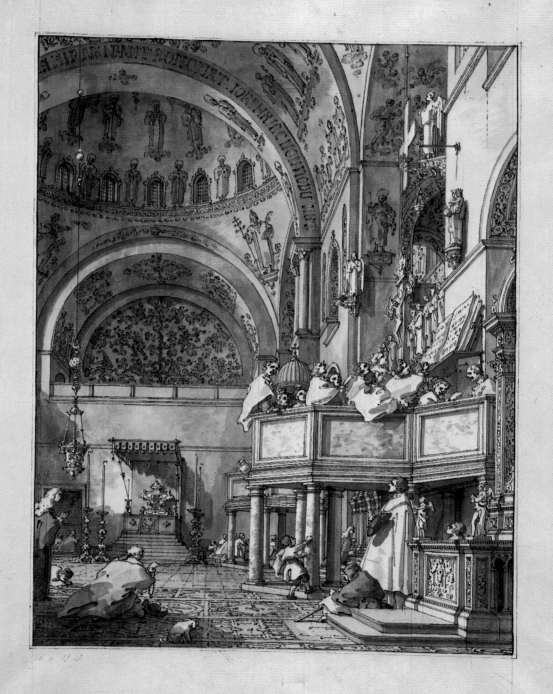

Io Zuane Antonio da Canal, Hò fatto il presente disegnio delli Musici che Canta nella Chiesa Ducal di S. Marco in Venezia, in età
Anni 68 Cenzza Ochiali, L'anno 1766.

# Canaletto's Technique

The first technical observation that should be made about Canaletto's production regards the large number of his works. The recent catalog compiled by Constable and Links (1976) lists no less than 521 paintings, 379 drawings (to which must be added the drawings in Canaletto's sketchbooks and his documentary sketches), and 35 etchings. It is evident that considering the number of works he produced and those that have survived Canaletto was an extremely prolific artist; moreover it is not really possible to identify in his work a "workshop" type of creative process, that is to say, a production in which works were mechanically handed over to assistants for the completion of minor portions and then completed with the master's finishing touches. Rather, the mass of derivations from Canaletto's prototypes (totaling at least three times the amount of paintings by the master himself) leads us to believe that his imitators and followers produced most of these works without his knowledge, using as models the numerous engravings of Canaletto's works which were available

at the time. In this respect Canaletto's nephew Bernardo Bellotto occupied a unique position; he was Canaletto's only documented assistant for the brief period of his apprenticeship (1738–43) and in fact was probably expelled from the master's workshop for his excessive skill in copying his uncle's works.

Canaletto's pictorial technique was oil on canvas; the very rare exceptions to this are a small number of panels and copperplates. Painting over a light preparation, Canaletto achieved a highly luminous transparency in his colors, in contrast to Ricci before him and Guardi after, who often used a priming of "Armenian clay." Because of this type of preparation of his canvases, the surfaces of Canaletto's paintings are often in an excellent state of preservation and have a corporeal, enamel-like, fairly consistent quality, even in the less clear areas.

In considering Canaletto's technique, we cannot neglect his draftsmanship, particularly in light of the large number of his drawings that have survived. For his drawings, Canaletto generally used white laid paper, availing himself of the lumi-

139

nous qualities of the paper itself in the areas which he left blank. Canaletto's drawings can be divided into three main categories:

1. His *documentary drawings,* originally contained in sketchbooks, which are numbered and bear annotations regarding vantage point, angle, and color (for example, the drawings in the sketchbook in the Academy in Venice). These drawings are usually in black chalk, gone over with ink (perhaps in the studio). They are probably Canaletto's only drawings from life, and it is in regarding them that the question of the "optical chamber" comes up. We have amply discussed the various theories regarding this instrument, which was used an an auxiliary element to photographically define the dimensions of a view. In our opinion it could have been of only secondary importance in Canaletto's creative process, which found better expression in his more formal drawings (discussed later).

2. The second category is that of Canaletto's *preparatory drawings,* that is to say, sketches from the artist's imagination, in which the extreme freedom and agility of his hand categorically eliminate the possible use of auxiliary optical devices. The medium of these drawings is generally pen and ink (for example, the drawing in Philadelphia of the fishmarket).

3. The third type are the *finished drawings,* that is, ones that were destined for collections (for example, many of the drawings at Windsor). These are usually of quite large dimensions and constitute works of art in themselves; they are often carried out with painterly techniques, in chalk, pen and ink, and washes in various shades of brown and sepia. Canaletto

used different types of ink for his drawings: from carbon black, with its various shades of brown according to how he diluted it, to the gray and black tones derived from sepia ink. We more rarely find evidence of Canaletto using iron or India ink.

Canaletto's use of ink is also varied by different pens, which are often hard to identify precisely. Von Hadeln (1930) and Parker (1948) have pointed out the preponderant use of quill pens (goose, turkey, swan, peacock, rook, and crow), the alternative use of sharpened reed pens, and the rare use of metal pens (which were beginning to come into use in the eighteenth century).
Canaletto's drawings were executed freehand, but he also used special tracing techniques such as invisible pinpricks, or lines marked with a drawing pen or compass (Parker, 1948).
All of Canaletto's engravings are etchings and were collected in a single volume dedicated to Consul Smith in 1744, though they were probably executed a few years earlier. His etchings have the simplified, linear quality of drawings rather than the more complex character of true engravings. Still, the technical refinement of Canaletto's etchings often was the result of touches added to the plates at later stages (up to the fourth), which usually attain more subtle pictorial effects in the shaded areas (Bromberg, 1974). Because of these refinements Canaletto's etchings constitute unsurpassed masterpieces of eighteenth century engraving.

# SELECTED BIBLIOGRAPHY
*(Chronological)*

P. A. ORLANDI & P. GUARIENTI
*Abecedario Pittorico*
Venice, 1753.
A. M. ZANETTI
*Della Pittura Veneziana...*
Venice, 1771.
L. LANZI
*Storia pittorica...*
Bassano, 1795.
J. RUSKIN
*Modern Painters*
London, 1843–60.
H. FOCILLON
*Piranesi*
Paris, 1918.
D. von HADELN
*Die Zeichnungen von Antonio Canal*
Vienna, 1930.
A. CALABI
*L'incisione italiana*
Milan, 1931.
M. PITTALUGA
"Le acqueforti del Canaletto"
in *L'arte,* 1934, p. 308.
H. FRITSCHE
*Bernardo Bellotto*
Burg b. M., 1936.
A. DE WITT
*L'incisione italiana*
Firenze, 1941.
R. PALLUCCHINI & G. F. GUARNATI
*Le Acqueforti del Canaletto...*
Venice, 1945.
K. T. PARKER
*The Drawings of Antonio Canal at Windsor Castle*
London, 1948.
F. J. B. WATSON
*Canaletto*
London, 1954.
E. POVOLEDO
Entry "Canal" in *Enciclopedia dello Spettacolo*
Rome, 1954, vol. II, p. 1625.

V. MOSCHINI
*Canaletto*
Milan, 1954.
T. PIGNATTI
*Il Quaderno dei disegni del Canaletto*
Milan, 1958.
D. GIOSEFFI
*Il Quaderno delle Gallerie Veneziane*
Trieste, 1958.
C. L. RAGGHIANTI
"Procedimenti del Canaletto"
in *Selearte,* 1959, n. 42, p. 33.
C. BRANDI
*Canaletto*
Milan, 1960.
R. PALLUCCHINI
*La pittura veneziana del Settecento*
Rome, 1960.
W. G. CONSTABLE
*Canaletto*
Oxford, 1962.
M. LEVEY
"Canaletto's Fourteen Paintings"
in *The Burlington Magazine,* 1962, p. 333.
F. HASKELL
*Patrons and Painters*
London, 1963.
V. MOSCHINI
*I grandi maestri del disegno: Canaletto*
Milan, 1963.
W. G. CONSTABLE
*Canaletto*
Toronto, Ottawa, Montreal, 1964–65.
A. MORASSI
"La giovinezza del Canaletto"
in *Arte Veneta,* 1966, p. 207.
T. PIGNATTI
"Gli inizi di Bernardo Bellotto"
in *Arte Veneta,* 1966, p. 218.
P. ZAMPETTI
*I Vedutisti Veneziani del Settecento*
Venice, 1967.

L. PUPPI
*Canaletto*
Milan, 1968.
T. PIGNATTI
*Canaletto, disegni scelti e annotati*
Florence, 1969.
F. VIVIAN
*Il Console Smith*
Vicenza, 1971.
S. KOZAKIEWICZ
*Bernardo Bellotto*
London, 1972.
R. PALLUCCHINI
"Per gli esordi del Canaletto"
in *Arte Veneta,* 1973, p. 155.
R. BROMBERG
*Canaletto's Etchings*
London, 1974.
A. CORBOZ
"Sur la preétendue objectiveé de Canaletto"
in *Arte Veneta,* 1974, p. 205.
W. G. CONSTABLE
*Canaletto* (revised by J. G. Links)
Oxford, 1976.
T. PIGNATTI
*Canaletto*
Florence, 1976.
J. G. LINKS
*Canaletto and His Patrons*
London, 1977.